In the book Utopian Communities of *Randy Soland's expertise in both history andags a new perspective to the fascinating stories of the Illinois communities that tried to build their own utopias. Soland's keen insights into human striving, as well as human imperfection, result in analyses of these important social experiments that are both informative and entertaining. As we continue to seek more perfect worlds, this book provides useful exemplars, inspirational and cautionary tales at the same time.*

—Ed Hoffman,
Retired Professor of Psychology at Northwestern University and Kenyon College

Utopian Communities of Illinois: Heaven on the Prairie *gives us a unique look into the minds of religious zealots who wielded extraordinary control over their willing followers. While much of this rich Illinois history has been lost through the passage of time, Randy Soland brings it to life through thorough research and vivid detail. The reader is left with a much better understanding of these so-called utopian communities and their special place in the Prairie State's growth.*

—Barry J. Locher,
Former Editor, State Journal-Register,
Springfield, Illinois

Randy Soland's book is very informative and educational. This is the first time I have ever read a comparative history about this topic focusing on both the leaders and communities. Having all the different histories of each group available in one book is a wonderful contribution. Reading this book has been both rewarding and enjoyable. Mr. Soland has presented a balanced examination of all the leaders, analyzing both their good and not-so-good personality styles and attributes. Like Richard Bushman (biographer of Joseph Smith), he has tried to give a fair account of Joseph Smith, yet Mr. Soland's admiration of Joseph shows through. I particularly enjoyed learning how Joseph Smith and the Mormons at Nauvoo compared with the other utopian communes in Illinois. I highly recommend this book to tourists visiting the communities of Nauvoo, Bishop Hill, Pullman and Zion; those interested in communes and utopias; and for any of my brothers and sisters in the Church of Jesus Christ of Latter-day Saints who are interested in learning more about Joseph and our Church's history.

—Estel Neff,
Great-Great-Great-Grandson of Katherine Smith Salisbury
(sister of Joseph and Hyrum Smith),
Member of the Church of Jesus Christ of Latter-day Saints,
Owner of Neff's Old House Bookstore in Nauvoo, Illinois

Published by The History Press
Charleston, SC
www.historypress.net

Top middle front cover image courtesy Frank Beberdick and the Historic Pullman Foundation. Legion image on back cover courtesy Princeton Library, Special Collections.

All images courtesy of the author unless otherwise indicated.

First published 2017

Manufactured in the United States

ISBN 9781467137225

Library of Congress Control Number: 2017934942

To Edward Hoffman, Joseph Johnstun, Barry Locher and Jody Soland, all of whose assistance was much appreciated by the author.

CONTENTS

UTOPIAS AND COMMUNES

Between 1663 and 1963, 516 communal experiments were started in North America—16 in Illinois. Before 1840, these communities were known as "communist and socialist settlements." By 1860, the term *communal* had changed to *communitarian*, and around 1920, the phrase *intentional community* became the moniker in vogue. After 1960, the designation changed again to *communes*. Whatever they were called, they were all of the utopian tradition. Utopianism is embedded in the American dream, "the land of opportunity," the "New World experiment" and "American exceptionalism."[1] America was made up of relatively inexpensive and unspoiled land, providing opportunity for social experimentation. Communitarians who failed in one place could find land and opportunity in another. In the United States, most of the communes were established between 1800 and 1850, as the United States was experiencing sweeping changes in transportation, communication, education, social and cultural norms, economics, politics and religion. These changes provided fertile ground for exploration for both American and European communitarian leaders possessing utopian ideals.

Approximately 120 communitarian communities were established during this fifty-year period; 24 of those communities were successful, and one of them, the Mormons in Nauvoo, Illinois, evolved into an established religion in American society. These communities were generally solidly Christian and strongly motivated by the leaders' beliefs in attaining Christian perfection, classified by historians as "Christian Socialism."[2]

INTRODUCTION

There were six communitarian groups founded in Illinois between 1839 and 1901: the Mormons and the Icarians at Nauvoo in Hancock County, the Janssonists at Bishop Hill in Henry County, the Fourierists at Loami in Sangamon County, the employees of the Pullman Railroad Car Company at Pullman in Cook County and the Dowietes at Zion in Lake County. Three of the six communities were religion-based and the other three secular.

These communities were all similar in one crucial respect: the integral role a strong leader played in their founding. This book attempts to answer certain questions: Who were the leaders of these utopian communities? Were these men true visionary leaders? All but the Mormons failed in their attempt to create a lasting community of true believers, and the only leader in this group whom most Americans have heard of is Joseph Smith.

A utopia is defined as a community or society possessing highly desirable or nearly perfect qualities. The word originated with Sir Thomas More, whose book *Utopia*, published in 1516, described a fictional island in the Atlantic Ocean. The general term is used to describe both fictional and actual communities that attempt to create an ideal society.

Communitarianism is a philosophy that emphasizes the connection between individual and community in a given geographical region and/ or possessing a shared history or interest. The general assumption is that individuals are products more of their community relationships than their individual temperaments. Communitarianism can be subdivided into two major categories: where the main focus is religious or where the main focus is secular.

The history of communes in the United States can be divided into three main periods:

1. The period beginning in the seventeenth century, when the founders arrived from Europe with their communal ideas, ending with the introduction of the Shakers in 1787. These communes existed in complete isolation in the New World.
2. A period of coexistence that lasted for one hundred years, between approximately 1780 and 1880, when people continued to arrive from Europe to start communes (though American communes were being established as well).
3. The period in which communes were formed by groups of native-born Americans inspired by utopian ideas and influenced by local events. This period of indigenous communes began in the 1880s and has continued to the present.

Even when American communes flourished, the commune and its lifestyle never truly endangered American society. Furthermore, there does not seem to be a major impact in relation to communes and the course of American history, except for the Mormons, who led American expansion into the West after their departure from Nauvoo.

The inherent pluralism of American values, far removed from the communal world, did not impede communal beginnings and existence. For scores of believers, communal utopias remained rays of hope for a "Kingdom of Heaven" on Earth and/or a nuclei for an alternative society within a society.[3] The utopian leaders and followers in Illinois attempted to create a "Heaven on the Prairie."

JOSEPH SMITH AND THE MORMONS AT NAUVOO, 1839–1846

Joseph Smith Jr. was born in Sharon, Vermont, on December 23, 1805, the fourth of ten children. His father, Joseph Smith Sr., was from a poor and undistinguished family, while his mother, Lucy Mack Smith, was from a prominent and well-to-do family. Young Joseph grew up in an environment of economic deprivation. His family moved nineteen times in the ten years prior to settling in Palmyra, New York, in 1816. Smith Sr. made a living farming and once, briefly, managed a village store. Before the move to New York, Smith Sr. had even tried to import ginger commercially but was swindled by his business partner and his partner's son. At Palmyra, Joseph Smith Sr. owned a bread and beer shop until it failed, and then he returned to farming.

Although Smith Sr. worked hard, his prosperity did not increase. Perhaps in an attempt to improve family finances, Smith and his sons spent much of their free time hunting for buried treasure. At that time, treasure hunting was a common avocation of many area residents, stimulated by local folk tales and legends that treasure buried by Indians and Spanish and English pirates was waiting to be found. Stone, copper and especially silver were dug up from local Indian burial mounds, which helped strengthen the legends. Detection tools such as divining rods or "peek," "peep" or "seer" stones (smooth stones found near Palmyra) were popular. Holders of the seer stones believed that by gazing intently into them, one could locate buried treasure.[1]

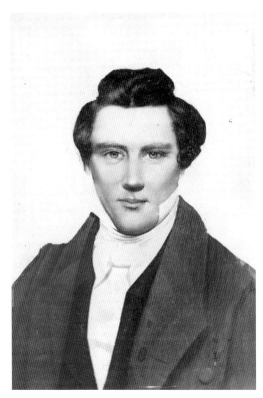

Left: Joseph Smith. *Courtesy of the Library of Congress.*

Below: Joseph Smith Home, Nauvoo. *Courtesy of the Library of Congress.*

Religion was an important aspect of the Smiths' lives. Smith Sr. often reported his dreams and visions to his family. Joseph's mother was very pious, devoutly reading the Bible to her children and intensely praying. In 1820, a new wave of religious revivalism hit western New York. Methodist, Baptist and Presbyterian evangelists competed against one another in camp meetings and revival services. The Smiths were swept up in the movement, and five members of the Smith family joined the Presbyterian Church. Joseph Smith Jr. refused to join any church but did attend the camp meetings.

Most of Joseph Smith Jr.'s youth was spent in land clearing, plowing, maple sugar gathering and home and barn raising, as well as other heavy manual labor. He was barely literate. Orson Pratt, one of his biographers and followers, could find no evidence that his education extended beyond the most elementary knowledge of the three Rs. Many Mormons have claimed that his lack of education is proof of divine inspiration for his achievements.[2]

One day in 1820, Joseph Jr. returned home after visiting a nearby woods and excitedly told his family of a most unusual spiritual experience. He reported that he had knelt down in prayer and that two personages had spoken to him, announcing that they were Jesus the Savior and God the Father and telling him that all existing churches and their beliefs were false and that he should not accept any of them."[3] This experience has come to be called the "First Vision" by the Mormons.

On September 21, 1823, Joseph Jr. reported that he had another vision in which an angel named Moroni visited him. Smith stated that he was told by Moroni that "God had work for me to do, and that my name should be had for good and evil spoken of among all people."[4] Moroni went on to tell Joseph Jr. of a book, written on gold plates, that gave an account of the former inhabitants of this continent and their origins. Moroni said that the fullness of the gospel personally delivered by the Savior to the ancient inhabitants of America was contained in the book. Smith also said that two stones in silver bows (called by Moroni the "Urim" and "Thummim") were left with the plates, fastened to a breastplate. Smith claimed that he used these stones to translate the plates and that earlier these same stones had been used by the ancient Hebrew priests to determine God's will as expressed in the Old Testament. According to Smith:

> *After telling me these things, he commenced quoting the prophecies of the Old Testament. Again, he told me, that when I got these plates of which he had spoken, I should not show them to any person, neither the breastplate with the Urim and Thummim, only to those commanded to show them; if*

I did otherwise I should be destroyed. While conversing with me about the plates…I could see the places where the plates were deposited and that so clearly and distinctly that I knew the place again when I visited it.[5]

The circumstances regarding the finding of the plates are problematic for obvious reasons and are compounded by the conflicting accounts Smith gave during his lifetime. Smith's recounting of the "First Vision" and the visit from Moroni also suffer from the same problem of reliability with the connected changing stories told by Smith over time. Whether the accounts vary due to Smith's deliberate fabrication or faulty memory depends on one's point of view. For example, in variations of Smith's story, the plates were metallic, then gold and then finally described as engraved golden plates. There is no hard evidence that the plates ever existed.

In 1827, from behind a curtain and allegedly first using the "Urim" and "Thummim" for the first 116 pages and then afterward looking into a hat and using a favorite chocolate-brown "seer" stone, Smith orally translated the plates, first using his wife, Emma, and then her brother, Reuben Hale, as scribes. A local farmer, Martin Harris, became his scribe in 1828, and in 1829, Oliver Cowdery—book peddler, printer and schoolteacher and third cousin of Joseph Smith Jr.—took over as scribe. David Whitmer took over as scribe for the last 150 pages, and the translation was completed in June 1829. Later in 1829, after hours of prayer and meditation, Oliver Cowdery, Martin Harris and David Whitmer were taken by Smith into nearby woods and shown the plates. Later, the three men signed an affidavit that they had seen the plates. After translation of the plates was completed and shown to the "Three Witnesses," as they came to be called, an angel appeared and took away the plates and the stones.[6]

Martin Harris and the Whitmer family put up the cash for publication of the translated plates. On March 26, 1830, *The Book of Mormon: An Account Written by the Hand of Mormon Upon Plates Taken from the Plates of Nephi* was published. The first edition contained the entry, "By Joseph Smith Junior, author and proprietor," but subsequent editions omitted it. This text purported to contain the writings of ancient prophets who lived on the American continent from 600 BC to AD 421, written in what Joseph Smith called "reformed Egyptian."

The Book of Mormon, as it is more simply known, told the story of the descendants of a Hebrew family who left Jerusalem around 600 BC. The father, Lehi, had been spiritually inspired to flee the city, which was doomed to destruction by the Babylonians. Building a ship, the family crossed the

ocean and landed in America. From this family arose two nations known as the Nephites and the Lamanites.

In general, the Nephites were a God-fearing people, while the Lamanites were quarrelsome and wicked. The Nephites preserved the history of Israel up to the time the family left Jerusalem. They kept records of their own nation, as well as translations of writings from other civilizations they had encountered. Their prophets and priests taught them the principles of righteousness and administered the religious ordinances. As Israelites, they obeyed the law of Moses and, in the prophetic tradition of their forefathers, believed in the coming of a Messiah. After Christ's death and resurrection in Palestine, Christ appeared to the inhabitants of the New World, preached and performed miracles and laid the foundation of another church, just as he had done in Palestine.

Following the appearance and teachings of Christ, the Nephites and Lamanites lived in peace and happiness for generations. But as they grew more prosperous and worldly, they became wicked, despite the continual warnings of many prophets. One such prophet was Mormon, who kept the records of the nation. From his extensive records he made an abridged version on the plates. He gave this history to his son, Moroni, who survived the complete destruction of the Nephites by the Lamanites. Moroni buried these plates in the hill called Cumorah, where Joseph Smith Jr. found them fourteen centuries later.[7]

How could Smith have obtained the ideas for the six-hundred-page Book of Mormon? For devout Mormons, the answer is simple: Joseph Smith Jr. was chosen to be a prophet for God and to reestablish his church on Earth. For non-Mormons, the answer is not so simple. One explanation is that the Book of Mormon is an adaption of an unpublished novel written by Solomon Spaulding, a Revolutionary War veteran, bankrupt land speculator and ex-preacher. Prior to his death, Spaulding complained to his friends and family that a draft of his novel, "A Manuscript Found," had been stolen by Sidney Rigdon from the shelves of Pittsburgh, Pennsylvania publisher R. and J. Patterson. Spaulding's book was about a group of Romans blown off course on their journey to Britain who arrive instead in America. Their descendants broke into two nations near the Ohio River. After a long peace between the nations, a prince of one nation elopes with the princess of the other nation. This results in a long war between the nations, the loss of much life and the eventual triumph of the prince and princess.[8]

Sidney Rigdon was one of the three principal founders of Mormonism along with Joseph Smith Jr. and Oliver Cowdery. Rigdon, an ex-Campbellite

minister, was considered a great orator, preacher and biblical scholar. Some evidence exists that in 1826, Cowdery first brought Rigdon and Smith together. However, the current Mormon Church teachings hold that Smith and Rigdon did not meet until 1830.

Another persistent theory about the origin of the Book of Mormon was advanced by an ex-Mormon, Philastus Hurlburt, who believed that Sidney Rigdon wrote the Book of Mormon and gave it to Smith, who simply recited it to his scribes. Yet another theory is that Smith plagiarized a manuscript written by Reverend Ethan Smith (no relation), a congregational minister from Poultney, Vermont. In 1823, Ethan Smith published a book titled *Views of the Hebrews or the Ten Tribes of Israel in America*, which argued that the American Indians were of Israelite origin. Oliver Cowdery attended the church where Ethan Smith was the pastor before coming to link up with his cousin, Joseph Smith.[9]

Fawn Brodie, one of Joseph Smith's most eminent biographers, portrays Joseph Smith Jr. in her book *No Man Knows My History* as an uneducated but highly imaginative and creative man who wrote the Book of Mormon to impress his wife and gain financially. Brodie speculated that sometime during the translation of the book, Smith became convinced by his own powers of persuasion and decided to begin a new church. Some psychohistorians consider much of the Book of Mormon as a product of Smith's unconscious mind. Perhaps dreams told to him by his grandfather and his father; his own

Above: Joseph, Hyrum and Emma Smith grave site, Nauvoo.

Opposite, bottom: Joseph Smith Homestead, Nauvoo.

Joseph Smith Mansion Home, Nauvoo.

study of the Bible; common Indian legends heard in western New York; stories of the pirate Captain Kidd; and the economic, political and social ideas of his own day all came together in his mind to produce the book. Whatever the origin of the Book of Mormon, its publication raised doctrinal and procedural questions. For the believers, to resolve these issues, a formal organization and a church needed to be established.

A state charter was obtained, and on April 6, 1830, Joseph Jr., his brothers Hyrum and Samuel Smith, Oliver Cowdery and brothers Peter and David Whitmer met with their families and six other followers in Hyrum Smith's home to officially organize the Church of Christ. All present had been previously baptized. Smith offered the communion and "confirmed" those present by giving the gift of the Holy Ghost. Alexander Campbell, a famous contemporary of Smith's and founder of the Disciples of Christ, noted in 1830 that "Smith in the Book of Mormon decides all the great controversies…infant baptism, the Trinity, regeneration, repentance, justification, the fall of man, atonement, transubstantiation, fasting, penance, church government, the call to ministry, the general resurrection, eternal punishment, who may baptize, and even the question of free masonry, republican government, and the rights of man."[10]

Mormonism as an organized church with a comprehensive set of beliefs had come into existence. With their "restored gospel" now intact, the word was ready to be spread. Other members of the Smith family joined the church, as did some friends and neighbors.

In 1830, four Mormon missionaries sent by Smith to preach to the Indians in Missouri stopped at Kirtland, Ohio. According to church documentation, there they met Sidney Rigdon and his followers. Rigdon proclaimed the truthfulness of the Book of Mormon and was baptized, and the church subsequently converted hundreds of the Campbellites to Mormonism. Skeptics have argued that these conversions were prearranged by Smith and Rigdon.

This missionary success in the Western Reserve area of northern Ohio caused Smith and the New York Mormons to move to Kirtland, Ohio, in February 1831. Smith established two church headquarters, one in Ohio and the other in Missouri. He also sent missionaries to the rest of America and the British Isles. However, dissension among the Mormons and their non-Mormon neighbors, the economic Panic of 1837, mismanagement of Mormon business and church finances, the failure of the church-owned Kirtland Safety Society Bank and charges of banking fraud caused huge problems. In addition, Smith was accused of having a sexual relationship with Nancy Miranda Johnson, the sixteen-year-

old daughter of one of his church members, and engaging in a fraudulent land scheme along with Sidney Rigdon that resulted in Smith nearly being castrated; instead, he and Rigdon were tarred and feathered and beaten by some of the dissidents. All of these problems caused Smith and his followers in Kirtland to flee to Far West, Missouri, in January 1838. This setback caused most of Smith's original twelve apostles and half of its membership to leave the church.

The previous Missouri settlers, who were mainly from the southern states of the country, were alarmed by the sudden influx of Mormons. These Mormons, from New York and Ohio, were mainly antislavery and emancipationists, in stark contrast to their proslavery neighbors. The Mormons came to be viewed as a threat to existing social, religious and economic stability. Some episodes of violence against the Mormons occurred (e.g., tarrings, whippings, kidnappings, murders and the burning and destruction of Mormon homes). To protect themselves, Smith created the Danites, also called the "Armies of Israel," and a subgroup called the "Avenging Angels"—both defensive vigilante groups. The "Mormon War" of 1838 probably resulted in the death of twenty-one Mormons and one Missourian. Some estimates believe that between fifty and perhaps one hundred Mormon deaths are a more accurate accounting. Things came to a head with the expulsion of the church from Missouri under the "Extermination Order" of Governor Lilburn W. Boggs on October 26, 1838. Boggs proclaimed, "The Mormons must be treated as enemies and must be exterminated or driven from the state if necessary, for the public peace."[11]

In November 1838, Smith and several other Mormon leaders were arrested and jailed in Liberty, Missouri, charged with murder, treason, burglary, arson, larceny and theft. In January 1839, Mormon apostle Brigham Young fled, along with four hundred followers, across the Mississippi River to Quincy, Illinois. Eventually, a total of eight thousand Mormons came to Quincy, where the citizens offered their sympathy and assistance by opening up their homes and hearths, giving the Mormons food, clothing and shelter. On April 15, 1839, while being transferred to Boone County, Missouri, Smith and other church leaders were allowed to escape while three of the guards purposefully got drunk on whiskey and passed out—a fourth helped them saddle some horses to flee to Quincy. After Smith joined his family in Quincy, he began searching for a new home for his people. The Mississippi River towns of Commerce, Illinois, and Montrose, Iowa, fifty miles north, appealed to him. Land was relatively cheap there, and existing settlement in each area was sparse. Commerce only had six or seven dwellings at the time.

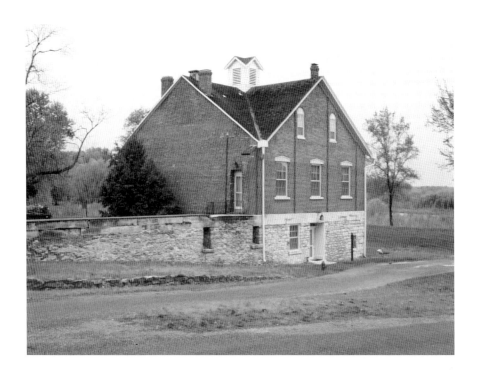

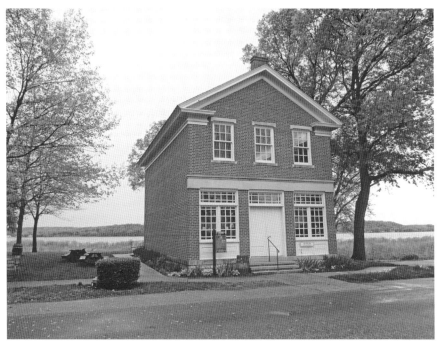

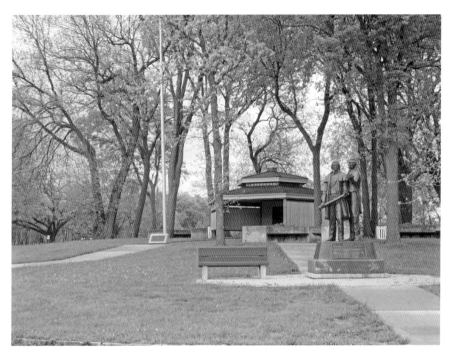

Above: Site of Mormon Crossing.

Opposite, top: Nauvoo House Hotel.

Opposite, bottom: Red Brick Store, Nauvoo.

Isaac Galland, who was living in Commerce, met with Israel Barlow, a Mormon who had come to Commerce as a refugee from Missouri, to check out the area for possible settlement. Galland was a doctor, merchant, postmaster and real estate agent. The Mormon settlement in Commerce began when Joseph Smith and his family moved there on May 10, 1839. Smith renamed the city Nauvoo, which Smith said meant "beautiful" in Hebrew. George W. Robinson—first secretary to the First Presidency of the church, a leader of the Danites and one of the official church history recorders in the 1830s—actually came up with the new name.[12] The deciding factor for Smith in choosing the location of a new gathering place was the opportunity to purchase the land that Galland had for sale for no money down and a long-term mortgage.

Smith bought 2,638 acres of land on the Illinois side of the river and 12,745 acres of land on the Iowa side of the river for $6,600 and $32,342, respectively. In addition, Joseph, his brother Hyrum Smith and Sidney

Rigdon purchased 500 more acres from Commerce residents, amounting to a total of $114,500. The total loan amount for all of the acreage was to be paid back over a period of twenty years. Smith and the church were now prepared to enter the real estate business on a large scale, by selling 1-acre lots on 4-acre city blocks in order to accommodate church members. On those lots, families could have a wood or brick home with outbuildings, a garden, an orchard and a grazing plot—or even use a lot for a business. In 1841, Smith called all members of the church to move to the Nauvoo area.

Nauvoo was to be the new church center, with an additional seventeen planned communities to surround Nauvoo like spokes on a wheel. The prophet's design was a simple grid conforming to the lines of an established survey. Nauvoo developed quickly; by June 1840, there were about three thousand people living in 250 houses.

Between 1839 and 1841, 299 Mormons died of diseases such as pneumonia, whooping cough, malaria, diarrhea from cholera, typhus and tuberculosis. To improve the living environment, an irrigation canal was constructed to drain the eighty-eight-acre swampy bottomland, or "Flats," as it was called. By 1842, Nauvoo's population had grown to 4,000 and by 1845 to 10,000, with 4,733 Mormons having emigrated from Great Britain.

Under Smith's leadership, the Mormons donated their labor and provided the capital to build a large hotel, sawmills, a flour mill, a tool factory, a foundry and a pottery factory. By 1844, there were 2,200 buildings, 300 of them brick. The largest project was the building of the Mormon temple, which began in 1841 and was functionally completed in 1846; $1 million was raised for its construction. The building combined Venetian, Egyptian, Grecian and Byzantine architecture. It was built of gray limestone from a nearby quarry and had a baptismal font with twelve carved oxen. The temple measured 88 feet wide and 128 feet long and was 165 feet high.

The state legislature granted recognition to the city government in 1840 and also chartered a joint-stock corporation called the Nauvoo Agricultural and Mechanical Association to promote local farming and industry. A large community field, where landless Mormons could farm, attracted those who hoped to earn enough money to eventually purchase their own land in or around Nauvoo. While in Kirtland, Ohio, the Mormons attempted to create a land ownership chain with tenure given for services, while heirs were prevented from direct inheritance. Non-Mormon farmers, however, preferred family-based autonomy. They had little understanding, sympathy or empathy for communal living and viewed it as a threat to their own economic prosperity.

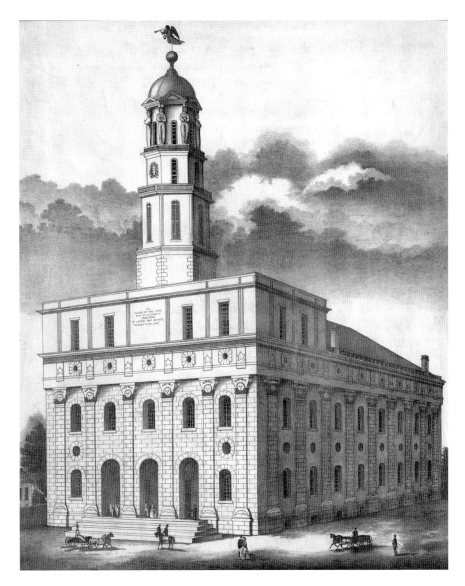

Nauvoo temple. *Courtesy of the Library of Congress.*

Every Nauvoo farmer needed a few oxen or horses to pull plows or wagons to haul their crops to barns, mills and markets. Some farmers combined both grazing and cultivation on their land. To feed their families, every farmer and most city residents kept a cow to provide milk and, in turn, used the milk to make butter and cheese. Hogs and sheep were kept for meat, and chickens were raised for both eggs and meat. Some residents hunted

the nearby woods, prairie and river corridor for game birds, waterfowl, deer, rabbit and squirrel. The Mississippi River and nearby streams provided fish.

Farmers raised corn, wheat, hemp, oats, buckwheat and potatoes, with foods made from either corn or wheat usually found on every kitchen table at meal time. Corn was the primary food for the citizens of Nauvoo in both summer and winter. Cornmeal was baked into bread, fried as corn pone or boiled as mush. Fruit trees, berries and vegetables were grown on every resident's property to be eaten when ready or canned for later use.

In 1840, in order to expand church membership, Smith sent Brigham Young to join Heber C. Kimball in England to bring new members into the church and encourage them to come to Nauvoo. A deepening economic depression in Great Britain provided many willing converts. Between 1837 and 1846, Mormon missionaries in Great Britain baptized almost 18,000 British citizens from England, Scotland and Wales, of whom 4,733 immigrated to Nauvoo. As a result, Nauvoo became the second-largest city in the state of Illinois and the thirty-eighth-largest city in the nation. Population estimates for 1846 vary widely from 10,000 to 20,000, with the most accepted figure being between 10,000 and 12,000, with seven to eight thousand homes.

Nauvoo's population grew to include people from all walks of life: bakers, cobblers, wheelwrights, tinsmiths, merchants, farmers, craftsmen, lawyers, doctors, gunsmiths, blacksmiths, pharmacists, doctors, educators and businessmen. Nauvoo even had its own university, whose president was a graduate of Trinity College in Dublin. Courses taught at Nauvoo University included mathematics, science, languages, history, literature and religion. Nauvoo also attracted some criminals who found that by joining the church they could live in Nauvoo, continue their criminal practices on the non-Mormons in the area and use Nauvoo as a safe haven.

The Mormon economy was a radical departure from existing American economic practice. The Mormon Church was initially communitarian with the United Order of Enoch, a social and economic system created to provide brotherly love and charity and abolish poverty. The law of consecration and stewardship was given as a revelation to Joseph Smith on February 9, 1831. The law comprised four elements: economic equality, management of surplus individual incomes by the church, freedom of enterprise and group economic self-sufficiency.

In the early Mormon settlement at Kirtland, Ohio, and in the multiple Mormon settlements in Missouri, those joining the church were asked to "consecrate" their property and belongings to the church with a covenant

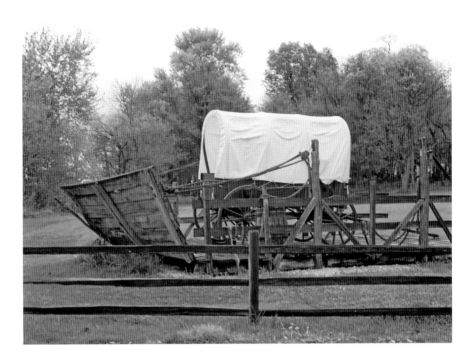

Above:
Barge with
wagon used
during the
Mormon
exodus.

Right:
Seventies
Hall,
Nauvoo.

Blacksmith Shop, Nauvoo.

and a deed that could not be broken. In return, the church made every member a steward over his own property—including any property one had received by consecration—up to as much as was sufficient for their family. Any surplus of any kind was kept by the church to distribute to those in need. However, the church did not attempt to control market or wage prices in any of the communities.

Eventually, rapid growth and affluence made the law of consecration and stewardship unpopular. Smith observed, "The law of consecration cannot be kept here and it is the will of the Lord that we should desist from trying to keep it. In Nauvoo, everyone is to be steward over his own."[13] One factor influencing Smith to change this practice was the refusal of the brethren in Ohio and Missouri to adhere to it. In fact, the observance of the law of consecration and stewardship was one of the reasons why one early founder, Oliver Cowdery, left the church on April 11, 1838. Cowdery also disagreed with Smith's use of church funds for personal benefit, differed on the separation of church and state and showed disgust with Smith's relationship with Fanny Algier (Smith's first plural wife, taken in 1835). Cowdery joined the Methodists but later returned to Mormon membership on November 12, 1848.

Yet the language and sentiments that were part of the consecration and stewardship system remained. The high point of the temple ceremonies

introduced in Nauvoo was the taking of the consecration covenant. Continuing today, church assignments are viewed as stewardships, with limited tenure given in the assignments, individual responsibility to magnify one's calling, periodic accounting to higher church officials and an understanding that such assignments are sacred callings from God.

Nauvoo also differed from earlier Mormon settlements in another important economic factor. Because Smith and the other church leaders had made direct investments in the land on credit, the church found itself with a serious and chronic cash flow problem. In addition, this shortage of financial resources was compounded by financial losses in Ohio and Missouri. As a result, in 1838, the law of tithing, acceptance of which is required to become a member of the church to this day, was officially adopted as a substitute for the law of consecration. Under the early law of tithing, 10 percent of the member's possessions and property at the time of baptism, as well as 10 percent of their annual income, was to be given to the church. Those who had no property or income were expected to labor one day in ten for the church. Later, the requirement to tithe 10 percent of one's possessions and property or to labor for the church every tenth day was ended, but the requirement to contribute 10 percent of one's income was retained. Economics became the first area in which the Mormons accommodated to American culture. Other accommodations in religious beliefs, politics and social norms would follow.

The years between 1839 and 1841 represented "an era of good feeling" among Mormons and their fellow Illinoisans. Initially, the Mormons in Illinois were in a favorable political position, wooed by both the Whigs and the Democrats.[14] The Whigs existed from 1830 to 1855. After the Whig Party ceased to exist, its members became members of either the Republican Party, founded in 1854, or the Constitutional Union Party, founded in 1860 (and dissolved the following year). The Democratic Party was founded chiefly by Martin Van Buren in 1828 and continues today.

The Illinois legislature did not overlook the fact that the Mormons represented a powerful bloc of voters, from which it hoped to curry votes and which it hoped to serve. A growing Illinois, in 1818, had become the twenty-first state to join the Union. New counties, cities and towns were springing up, with their citizens sparring for power and seeking political favors. Nauvoo was no exception. However, because the Mormons sought favors from both political parties, they eventually guaranteed themselves the animosity of whatever party did not receive their votes.

In 1841, the Illinois Twelfth General Assembly was given requests to enact charters for city incorporations. On December 18, 1841, state representatives

granted Nauvoo a Bill of Incorporation with a charter that empowered the mayor and aldermen of the Nauvoo City Council to pass any law they chose. The only stipulation was that the laws did not conflict directly with state or federal constitutions. The charter had other important features as well, including the municipal court of Nauvoo being given authority to grant writs of habeas corpus in all cases arising under the jurisdiction of the city council.

A writ of habeas corpus is a court order that allows a prisoner to be released from detention if a judge determines there to be a lack of sufficient cause or evidence. The Nauvoo court was free to issue writs to arrested persons, including Joseph Smith, regardless of the jurisdiction. Missouri officials continually tried to arrest Smith while he was living in Nauvoo and bring him back to Missouri to face various charges. Smith and other Mormons were protected from legal persecution because Nauvoo judges intervened using writs of habeas corpus.

The charter also granted the city the right to form an independent militia answerable only to the governor, called the Nauvoo Legion. Formed in 1841 as an arm of the state militia, it consisted of three thousand men organized into sixteen companies. Joseph Smith was given the rank of lieutenant general by the Illinois governor, Thomas Carlin. After the church's troubles in Missouri, Smith was eager to form a strong armed force to make anyone think twice before persecuting the Mormons. However, to non-Mormon citizens living in nearby towns, it seemed that the Mormons were both evading due process of the law and creating an armed state within the state of Illinois.

Despite a statewide trend of electing Democrats in the 1830s, Hancock County (including Nauvoo) remained a Whig stronghold; in the Congressional, gubernatorial and state legislative elections of 1838, the Whigs had won by three-to-two margins. The Mormons' move to Nauvoo seemed unlikely to change this pattern; in fact, the Mormons voted solidly for Whigs in the elections of 1840 and 1841. One politician who sought to lure the Mormon vote away from the Whigs was Stephen A. Douglas, then Illinois secretary of state, who hoped to become a United States congressman. Douglas had helped Smith and the Mormons on several occasions via favorable appointments and invalidating legal charges against Smith brought by Missouri.[15]

Douglas's strategic use of power and patronage produced results for him in 1842. Regarding the election of that year, Smith stated that the Mormons would continue voting as a bloc, they would vote for those who would serve them best and their votes would now be for the Democrats. Despite this

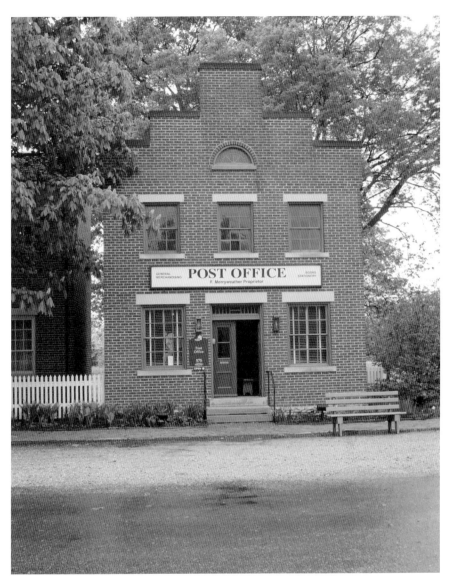

Post office, Nauvoo.

announcement, as the Congressional elections of 1843 approached, both political parties remained unsure of what the Mormons would do. In the election, Smith cast his vote for his personal friend, Cyrus Walker, a Whig, but told his brother Hyrum to urge the Mormons to vote as a bloc for the Democratic candidate, Joseph Hoge. The Mormon Democratic vote proved

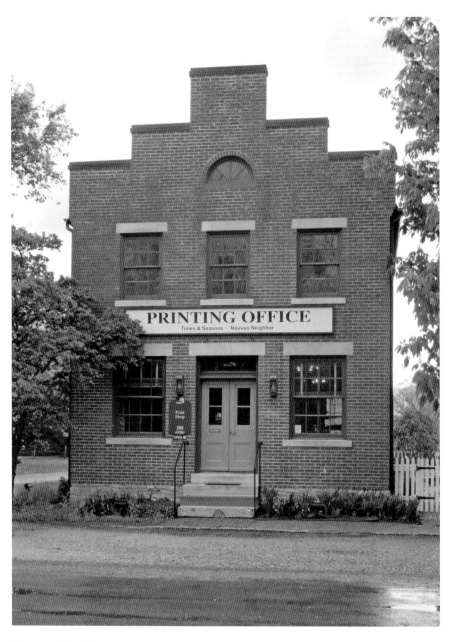

Printing office, Nauvoo.

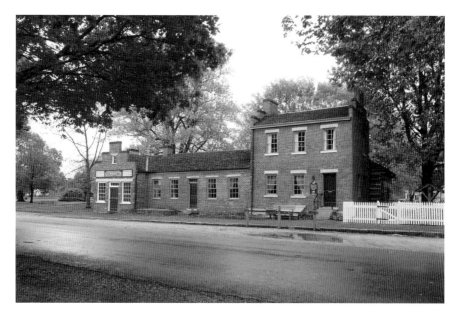

Jonathan Browning Home, Nauvoo.

decisive in 1843, and again in 1844, and contributed to the steady decline of Whig domination in western Illinois. Since Smith had previously directed the Mormon vote for the Whigs, their switch to the Democrats seemed a betrayal. The elections also opened the eyes of the non-Mormons to the political power and influence the Mormons now wielded within the state.

In 1844, Smith wrote to the two leading candidates for the United States presidency, Henry Clay and John C. Calhoun, asking them what pledges of protection they would offer the Mormons if elected. Both responded with evasive answers. As a result, Smith announced that he himself would become a candidate for president of the United States. His credibility as a candidate was enhanced by the Mormon missionary organization, which could also be utilized for electioneering purposes.

Smith favored ending slavery by 1850, to be achieved through government purchase of the slaves; the sale of public federal lands would provide funds to compensate the slave owners. He also favored the establishment of a national bank and the expansion of the country into the Oregon territory and Mexico. It would have been impossible for Smith to win the election, although his candidacy could have possibly pulled enough votes from the leading candidates to make a difference in the outcome. But before Smith could begin his campaign, a chain of events would change the course of the Mormon Church forever.

Smith's religious leadership was called into question by dissenting Mormons at the same time Smith was experiencing economic and political difficulties. Smith answered with new revelations leading to controversial doctrines, including the existence of multiple gods, new ceremonial temple rites and baptism for the dead—the latter ensured that deceased non-Mormons could be brought into the fold and receive the full spiritual benefits of being Mormon. In 1841, Smith revealed the formerly secretive practice of plural marriage or polygamy, which became the major explosive issue causing outrage among non-Mormons and dissension within the Mormon community itself.

These new rites for the Nauvoo temple were introduced, although not practiced until after Smith's death, including ceremonies of washing, anointing and sealing (uniting) in eternal marriage and family. Critics of the new rituals said they resembled Masonic temple ceremonies. Smith previously had spoken out against joining secret societies, as counseled in the Book of Mormon. In Nauvoo, he came to take a more pragmatic position, believing that some of his problems in Missouri could have been avoided if he had had more influence in high places—for example, by being a Mason. At that time, in both urban and rural communities in America, the most successful and powerful men were often Masons.

Smith attempted to gain favor and influence with non-Mormons by establishing a Masonic Lodge in Nauvoo in 1842. Eventually, 1,500 Mormons became Nauvoo Lodge Masons, their numbers exceeding the total number of Masons in the United States at that time. In addition, there were many other Nauvoo-area Masons who attended one of the other three Nauvoo lodges or a lodge in one of the nearby Mormon settlements.

On March 11, 1844, Smith established the "Council of Fifty" (also called the "Kingdom of God") to create a future theocratic government to govern after the return of Christ. Jesus would be the "King on Earth" of this new world government designed to be quasi-republican and multidenominational, consisting of both Mormons and non-Mormons. Regular meetings of the Council occurred until its cessation in 1884, although some historians believe that the organization continued until the death of church president Heber J. Grant in 1945.

On April 7, 1844, at the Mormon Church's general conference, Smith delivered a talk to twenty thousand Mormons that came to be known as the "King Follett" address or discourse. Three weeks earlier, Smith's good friend King Follett had been accidentally killed while digging a well. Follett's death inspired Smith to an even more revolutionary theology. He claimed that God had once been a mortal man who had evolved to become God.

Above: Calvin Pendleton Home and School, Nauvoo; *below*: Brigham Young Home, Nauvoo.

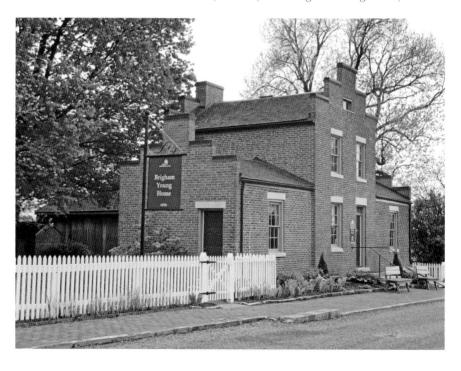

Scovil Bakery, Nauvoo.

Furthermore, all mortal men and women could become gods and goddesses themselves through salvation, exaltation and progression.

Smith ultimately collided with U.S. constitutional rights. In the spring of 1844, a group of Mormon dissidents founded an opposition group and started a newspaper. The dissidents became convinced that Smith was a fallen prophet because of his practice and advocacy of polygamy. The first and only edition of the *Nauvoo Expositor* was printed on June 7, 1844. It contained scandalous and derogatory allegations about the "adulteress" lives of Smith and other Mormon leaders. Smith and the city council declared the newspaper libelous and a public nuisance and ordered the town marshal to destroy the press and the Nauvoo Legion to stand by in case of trouble.

Smith's first plural wife was Fanny Algier in 1835 (while living in Kirtland), and his second plural marriage was with Lucinda Pendleton Morgan Harris in 1838 (while living in Missouri). The first recorded plural marriage in Nauvoo was between Joseph Smith and Louisa Beaman in 1841. By June 1844, when Joseph died, 29 men and 50 women had entered into plural marriage, in addition to Joseph Smith and his 40 plural wives. By the time

the Saints entered the Salt Lake City Valley in 1847, at least 196 men and 521 women had entered into plural marriage.

Smith's disregard for the freedom of the press and the destruction of the printing press angered the non-Mormons. The dissident Mormons filed charges at the county seat of Carthage, Illinois, accusing Smith of inciting a riot. A constable was sent to Nauvoo to arrest Smith. Joseph and his brother Hyrum, who was also charged, sought a change of venue. Their request was refused, but they obtained a writ of habeas corpus from the Nauvoo City Court. The Smith brothers were quickly tried and acquitted by the Nauvoo court. Anti-Mormons in Illinois, Iowa and Missouri were outraged, took up arms and headed for Carthage. An appeal for help was sent by Smith to Illinois governor Thomas Ford. The governor, a Democrat, had cooled toward the Mormons in recent months, fearing that his state would become the scene of a bloody civil war, much worse than in Missouri. Ford instead declared the destruction of the *Expositor* illegal and demanded that the Smith brothers come to Carthage for retrial. Ford warned that if they did not submit, Nauvoo and its citizens could be destroyed. Smith sought higher authority; he wrote a letter to the president of the United States, John Tyler, asking for federal assistance, arguing that the militias in Missouri and Illinois were joining in an insurrection against Nauvoo.

Joseph and Hyrum Smith, accompanied by their longtime friend and bodyguard, Porter Rockwell, and Apostle Willard Richards, fled by boat across the river to Montrose, Iowa. Joseph's wife Emma Smith sent word to Joseph about threats to Nauvoo from a state militia unit that had arrived in Nauvoo to arrest Smith, having just missed him. She added that Governor Ford would guarantee the safety of the Smith brothers if they turned themselves over to the authorities. According to Willard Richards, who was keeping Smith's personal journal, Smith stated, "If my life is of no value to my friends, it is none to myself," and, "I am going as a lamb to the slaughter."[16] The Smiths returned to Nauvoo and prepared to turn themselves over to the authorities.

On the road to Carthage, Smith and his party were met by a militia company sent by Governor Ford to confiscate the munitions of the Nauvoo Legion. Smith and his group briefly returned to Nauvoo to help the governor's men confiscate the arms. Finally arriving in Carthage around midnight, the Smith brothers were met by a crowd of local militia and citizens shouting threats of murder. The crowd was calmed by Governor Ford, and the Smiths spent the night in the Hamilton House Hotel. The next day, the troops of various militias were lined up for review by the governor. When the Smith

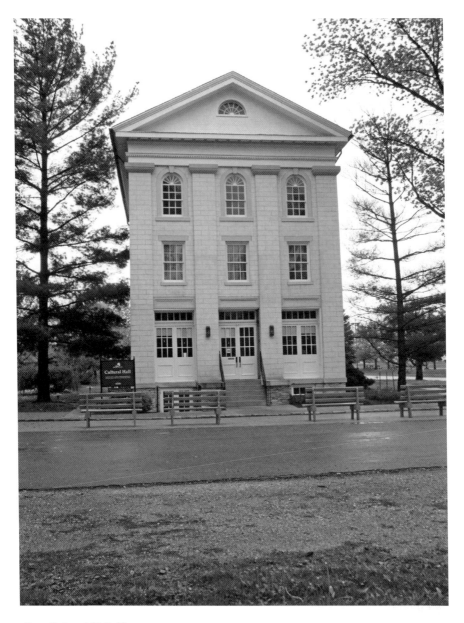

Above: Cultural Hall, Nauvoo.

Opposite, top: LDS Visitors' Center, Nauvoo.

Opposite, bottom: Nauvoo Quarry overlook.

brothers were brought out to be shown to the gathered mustered militia companies, the Carthage Greys almost mutinied and murdered the Smiths on the spot. Instead of being taken before Judge Morrison, who had issued the original writ of arrest, they were arraigned before Justice of the Peace Robert Smith, a well-known anti-Mormon and a captain of the Carthage Greys. Justice Smith set a high bail, which was promptly paid. Immediately after being released, the Smiths were arrested again, this time for treason on the grounds that Smith had wrongly declared martial law in Nauvoo during the destruction of the presses of the *Expositor*. The justice ordered the two brothers to be put in jail without bail. Eight friends of the Smith brothers chose to stay with them on the second floor of the two-story jail in Carthage. The trial was set for June 29. Over the next two days, Smith sent six of his eight friends on errands, perhaps to get them out of potential harm.

On the morning of June 27, 1844, Governor Ford left Carthage for Nauvoo to ask its citizens to submit peacefully to his plans for ending the trouble in the county to avoid a civil war. Ford had been accompanied by the only neutral group at Carthage, the militia from Augusta. Ford had assigned one of the most militant militias, the Carthage Greys, to guard the jail. The governor had disbanded and sent home the rest of the 1,300 men serving in the militias at Carthage. One militia unit from western Hancock County was on the way to Nauvoo to plunder and destroy the town when it received word from the governor to disband and return home. Instead, the majority of its members returned to Carthage.

Just after five o'clock that evening, a group of men approached the jail. The men on guard fired their guns in the air. One group of attackers stormed up the stairs and fired their guns into the room where Joseph, Hyrum, John Taylor and Willard Richards were staying. Joseph was able to wound three attackers with a smuggled-in pistol. Within three minutes, Hyrum and Joseph were killed and John Taylor was wounded. Willard Richards somehow was not shot in the hailstorm of bullets. Richards took John Taylor to an adjacent cell to hide him from the murderers. Instead of finishing the job by killing Taylor and Richards, the attackers fled the scene. Certain that the Mormons would retaliate, the citizens of Carthage evacuated the town.

The next day, June 28, the Smith brothers' bodies were taken to Nauvoo by their brother Samuel, as well as Willard Richards, Artois Hamilton and two of Hamilton's sons. Along the way, the party was met by a guard of eight members of the Nauvoo Legion. After a public funeral and display of the bodies in the Mansion House in Nauvoo, they were moved again and buried under the Nauvoo House, a hotel by the river, due to a fear of desecration

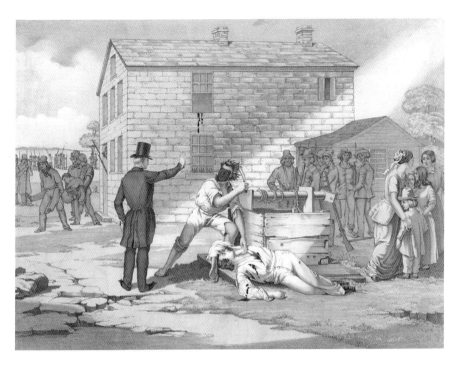

Martyrdom of Joseph Smith. *Courtesy of Library of Congress.*

of the bodies. The bodies were moved a total of four times before being reinterred in 1928 next to the original Joseph Smith homestead.

In January 1845, Nauvoo's special charter was revoked by the state, and the Nauvoo Legion was disbanded. In order to maintain some way of protecting the citizens of Nauvoo, the church leaders created the "Whistling and Whittling Brigade." The twofold purpose of this group was to protect the poor and keep the citizens of Nauvoo safe, especially at night. Suspicious strangers would be surrounded by groups of fifty to one hundred boys, armed with knives and sticks. The boys would follow them, whistling and whittling, without a question ever asked. The stranger would get the hint and quickly leave Nauvoo.

A power struggle developed within the church over who would be Smith's successor. The top contenders were Brigham Young, head of the Twelve Apostles, and Sidney Rigdon, then serving as first counselor in the First Presidency of the church. The Twelve Apostles and Brigham Young ran the church until 1847, when Brigham Young became the second prophet and president.

In January 1846, church leaders in Nauvoo heard news about pending attacks on Nauvoo citizens that would lead to the arrests of the Twelve Apostles, destruction of the temple and theft of the covered wagons that

were to be used in a planned move west. Because of these threats, the Twelve Apostles decided that church members should leave Nauvoo quickly rather than in the spring, as planned.

So, on February 4, 1846, the exodus across the Mississippi River began, with the Mormons floating wagons on barges across the river. On February 25, temperatures plummeted to well below zero, and the Mississippi River froze solidly enough to simply walk across. Two more groups departed in the spring and fall. By that autumn, Brigham Young and nearly the entire population of Nauvoo had crossed the river to begin the greatest migration in American history. Their journey ended in a region that would later become Salt Lake City, Utah. There the Mormons began anew what they had built in Nauvoo.

However, many dissident Mormons had not followed Brigham Young and the main body west. As many as one hundred splinter groups formed after 1844, some of which sects are still active today. Between 1830 and 1844, a total of nine groups split from Joseph Smith and the Mormons. Even Joseph Smith's wife Emma Smith, who disliked Brigham Young, remained in Nauvoo, where in 1847 she remarried a non-Mormon, Lewis Crum Bidemon, a law enforcement officer and businessman.

Opposite: Nauvoo Quarry.

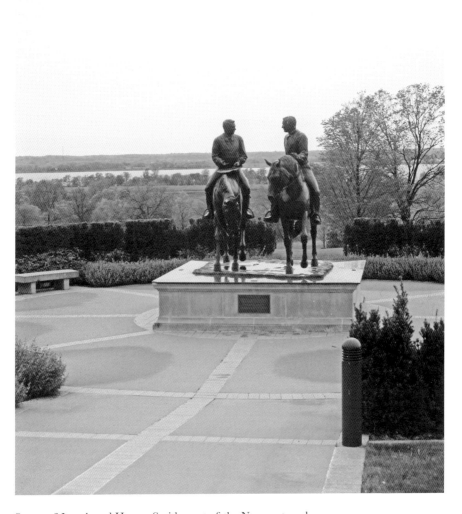

Statue of Joseph and Hyrum Smith, west of the Nauvoo temple.

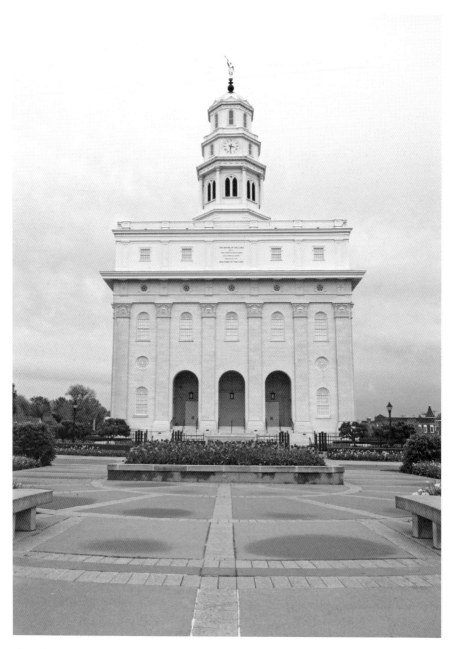

Above: Present-day Nauvoo temple front entrance.

Opposite: City of Nauvoo Visitors' Center.

One splinter church was started by William McLellin and David Whitmer. Another church, started by William Law (dissident and publisher of the *Nauvoo Expositor* newspaper), began and ended before the death of Smith in 1844. A third group went to Texas under Lyman Wright. A fourth group led by James Strang moved to Voree, Wisconsin.

However, the largest of the splinter groups was the Reorganized Church of Jesus Christ of Latter-day Saints (RLDS), founded in Beloit, Wisconsin, in 1852. Today, that church is called the Community of Christ. The split between the main body of the Mormons who went to Utah under the leadership of Brigham Young and the RLDS was primarily caused by disagreement over church leadership and succession following the death of Joseph Smith. Emma Smith believed that Joseph had wanted their son, Joseph Smith III, to assume the leadership of the church at some point. Having turned down the office multiple times, Joseph Smith III finally took over as president of the RLDS church on April 6, 1860.

Six months after the February exodus, in September 1846, there was a weeklong battle (the Battle of Nauvoo) between remaining Mormons and some non-Mormon town residents fighting attackers from nearby county state militias. When the battle ended on September 17, the last six hundred Nauvoo Mormons were driven out by gunpoint across the Mississippi River.

Above: The Hotel Nauvoo; *below*: Downtown Nauvoo.

Three Mormons and one attacker were killed, and several on both sides were wounded. Five Mormons were allowed to stay behind to try to sell the Mormon property.

For the most part, Nauvoo, with its beautiful homes and buildings, lay empty. The magnificent Mormon temple was set ablaze by an unknown arsonist in 1848, and two years later, a tornado completed its destruction. A new wave of communitarian emigrants from France calling themselves the Icarians came to Nauvoo in March 1849. After the tornado finished off the temple, some of the remaining non-Mormon residents and the newly arrived Icarians took the temple stones to use in their homes and buildings.

In 1962, Nauvoo Restoration Inc. was formed by Dr. LeRoy Kimball and the First Presidency of the LDS Church. Dr. Kimball served as president of Nauvoo Restoration Inc. from 1963 to 1987. He began acquisition of the land and buildings that had belonged to the Mormons in the 1840s. This plan of restoration continues into the twenty-first century.

Thirty houses and shops from the period have been restored and are open for free viewing to the public on all days but Christmas. Four

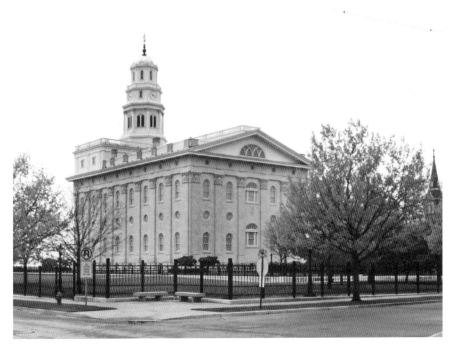

Nauvoo temple, southeast view.

Irrigation ditch, Nauvoo.

visitors' centers welcome tourists. Both the LDS and Community of Christ (formerly known as the Reorganized Church of Jesus Christ of Latter-day Saints) have their own visitors' centers. One fundamentalist Christian church has its own visitors' center and distributes anti-Mormon

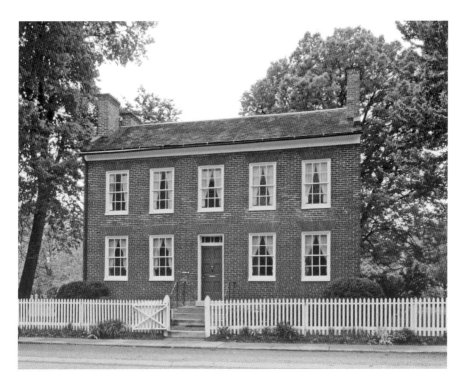

Wilford Woodruff Home, Nauvoo.

literature. Nauvoo also has a secular tourism center operated by the City of Nauvoo.

One can easily spend several days touring all the historic sites in Nauvoo and visiting the Old Carthage Jail. Visitors get a free brick at the restored Brick Yard (one per family), a free cookie at the Scovil Bakery and a small forged item at the Blacksmith Shop. There are also free horse- and oxen-drawn wagon rides where guides share informational and inspirational stories.

Approximately 250,000 tourists visit Nauvoo each year, primarily during the months of April through October. Every July, the church puts on two outdoor musical pageants: the Nauvoo Pageant and the British Pageant. Ongoing throughout the year are four plays depicting life in 1840s Nauvoo: *Rendezvous in Old Nauvoo*, *Just Plain Amanda*, *Sunset on the Mississippi* and *The Promise*. All pageants and plays are free and open to the public.

In 1999, then president of the Church of Jesus Christ of Latter-day Saints Gordon B. Hinckley announced the rebuilding of the Nauvoo temple. The rebuilt temple was completed on May 6, 2002, and opened to the general

Community of Christ Visitors' Center, Nauvoo.

Sacred Grove, Nauvoo.

Women's Garden at LDS Visitors' Center.

public for two months. Now the temple is only open to church members in good standing with "temple recommends."

The rebuilt temple functions as a regional temple for Mormons from Peoria, Illinois, to Des Moines, Iowa. Within the temple, ordinances such as baptism and confirmation for the dead, celestial (sometimes called "eternal") marriage for couples and sealing to family members both living and dead are conducted.

The Temple Block was purchased from the Catholic Church in 1961. In 1998, the LDS Church paid the Benedictine Order of the Catholic Church $6 million for an eighteen-and-a-half-acre site across the street from the Temple Block. That property was the site of St. Mary's Academy, a girls' boarding high school opened in 1874 and operated by Catholic Sisters of the Benedictine Order; the academy was subsequently demolished. In its place is a statue of Joseph and Hyrum Smith on horseback facing the temple, with a beautiful panoramic view of the Mississippi River as the backdrop. The temple itself cost the LDS Church $65 million to reconstruct.

The fifty-four-thousand-square-foot, white limestone temple is a powerful symbol to Mormon and non-Mormon alike, signaling the Mormons' return

Above: Baxter's Winery, Nauvoo; *below*: Lucy Mack Smith Home, Nauvoo.

to the land from which they were driven. To most non-Mormons living in Nauvoo, it presupposes a future when they may become the minority as Nauvoo once again becomes a predominantly Mormon town. The LDS Church, as well as Mormon individuals, has bought Nauvoo real estate at a rapid pace since 1999; by 2005, the Church of Jesus Christ of Latter-day Saints, the Community of Christ Church and individual Mormons held more than 80 percent of the land in Nauvoo, a larger percentage than in the 1840s.

Mormon history has, from its beginning, been filled with "us against them" conflicts. Although most Nauvoo residents accept the return of the Mormons, a minority continue to despise Mormons and actively resist the church in any way they can. The Mormon Church champions conservative values that, to some, seem to align more with American values of the 1950s, contrasting with today's generally liberal culture. In 2016, the church had nearly 16 million members around the world, with the majority of its members living outside the United States. However, only one-third of its members are active in the church.

The church has managed to avoid major conflicts with the larger American society by making accommodations. In 1890, a divine revelation came to the church president ending polygamy, which made it possible for Utah to finally become a state. In 1978, after another divine revelation, the

Nauvoo Brick Yard.

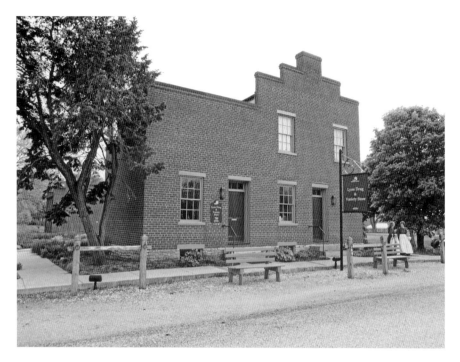

Lyon Drug and Variety Store, Nauvoo.

church lifted its ban against black men becoming priesthood holders while under social and political pressure and possible federal judicial action. Even as much of the country shifted to more liberal social attitudes in the 1960s and 1970s, the conservative church encouraged its members to vote against the Women's Equal Rights Amendment. The church still strongly opposes same-sex marriage, as well as abortion except in cases of rape, incest or the mother's health. Matters of birth control are left for individual members to decide, although Mormons are encouraged to have large families.

Nauvoo's population in 2016 was 1,118 and, like many other small midwestern towns, aging, with 47 percent of its residents being forty-five or older. There are few employment opportunities, with small farmers selling out to larger farmers and several non-Mormon businesses and the Nauvoo Cheese Factory (1937–2003) having closed. Likewise, the nearby Illinois towns of Carthage, Augusta, Hamilton and Warsaw and the Iowa towns of Fort Madison and Keokuk have been in steady economic decline since 1975. Only the tourist business has kept Nauvoo economically alive, with both Mormon and non-Mormon shops and small businesses surviving. Just as the Jews have returned to Israel, the Mormons have returned to Nauvoo. There

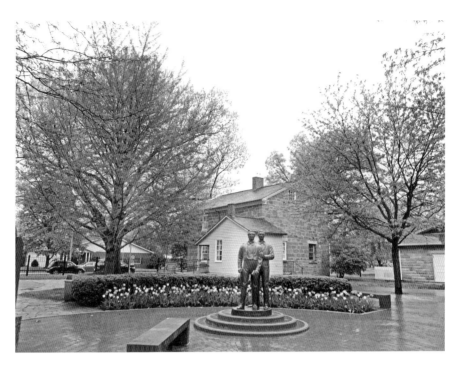

Above: Carthage Jail front entrance; *below*: Carthage Jail.

they are likely to continue to expand the tourism industry and create both a Mormon retirement community and a home for younger Mormon families wishing to live "the simple life," connect with their shared historical and cultural heritage and create new business ventures. Perhaps in time future economic growth to the area will come through the development of small cottage industries. Nauvoo has the potential to become a "Williamsburg of the Midwest." Only time will tell if Nauvoo will become so, or whether it will simply remain a small and cherished historical center of Mormonism.

ETIENNE CABET AND THE ICARIANS AT NAUVOO, 1849–1860

O n March 15, 1849, three years after the Mormons had started their exodus to the Utah territory, a new group of immigrants came up the Mississippi River from New Orleans. They were trying for a second time to build their utopia in the United States, the first attempt having failed in what is today Denton County, Texas, near Dallas. The Icarians were a French-born community whose numbers would reach about five hundred by the mid-1850s. They were determined followers of Etienne Cabet, a French writer and political radical. Cabet, who had abandoned the possibility of erecting a perfect community in his own country, turned to America as a setting for the realization of an ideal society, first described in his best-selling book, *Travels in Icaria*, published in Paris in 1840.

Etienne Cabet was born in Dijon, France, on January 1, 1788, the youngest son of a Burgundian cooper (a maker of wooden barrels). He was trained as a lawyer and became a government official, as well as a *procuruer-general*, in Corsica, representing the government of King Louis Philippe. Cabet headed an insurrectionary committee and participated in the July Revolution of 1830 that had overthrown King Charles X for King Louis Philippe. He also wrote *Historique de Revolution de 1830*, in which he attacked the conservative government. Cabet continued to be deeply involved in radical socialist politics, gaining election to the French Chamber of Deputies in 1831 as the representative of Côte d'Or (one

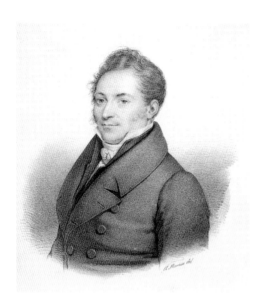

Picture of young Etienne Cabet.
Courtesy of Western Illinois University Baxter-Snyder Center for Icarian Studies.

of the original eighty-three governmental departments created after the 1790 French Revolution).

However, because of his outspoken criticism of the monarchy of King Louis Philippe, Cabet was convicted of treason in 1834 and sentenced to five years in exile, which he spent in London. While there, Cabet was influenced by reading both Thomas More's *Utopia* and literature about Robert Owen's communal settlement at New Harmony, Indiana.[1] When Cabet returned to Paris, it was with a manuscript for *Travels in Icaria* detailing his own new ideal social order. That book was translated into German, Spanish and English over the next eight years.

In Cabet's book, "Icaria" was depicted as a utopia established by a benevolent ruler, "the brave Icar." There, the evils of industrial capitalism would be eliminated by abolishing the root causes of all social disorder (e.g., private property, taxes, salaries and money itself) to achieve a democratically run welfare community. Its government, elected annually by the citizens, would control the production and distribution of food, organization of schools, construction of housing, building of highways and publication of newspapers.

All work in fictional Icaria, whether in workshops or on scientifically run farms, would be equal in importance, and each citizen was free to choose his or her profession. The colony would provide free and equal educational opportunity from childhood through adult life. Children were taken from their parents at an early age and were reared and taught by designated members of the community. Daily meals were delivered to the door of each household from the communal kitchen. Icaria followed the dictum, "To each according to his needs."[2] Everyone ate the same food, dressed in the same clothes and lived in the same type of housing. By Cabet's design, recreation was a public responsibility. Icarians, during their leisure time facilitated by short workdays (seven hours in the summer and six hours in the winter), were to enjoy picnics, festivals, concerts, plays and horseback riding.

Religion consisted primarily of the practice of the Icarian version of the Golden Rule: "Love your neighbor as yourself. Do not unto others the harm that you would not have others do to you. Do to others the good that you wish for yourself." Icaria, by any standard, was to be "idyllic, men and women were equal, and crime unknown."[3]

Cabet first thought of building his community in France, but the negative attitude of the French toward an equalitarian, class-free society convinced him that his idealistic plan for the brotherhood of all men, regardless of class, would prove impossible. The economic depression and food shortages that hit Europe in 1846 further exacerbated class tensions due to increases in food prices and rising unemployment.[4]

In the spring of 1847, Cabet made his decision. In the May issue of his newspaper, *Le Populaire*, he proclaimed, "Let's go to America!"[5] Over the next two years, seven groups of Icarians, totaling more than five hundred, left Le Havre, France, and headed for America. The first group of sixty-nine landed first in New Orleans, planning to organize a community in the Red River Valley of Texas. The conditions of living were hard; colonists contributed their money to the common fund and had to bring their own tools and clothing for the voyage, which usually took two months. Upon arrival in Texas, they found that they had been duped by the Peters Land Company. Instead of being near the Red River, they were given land that was 250 miles away, totaling 320 acres instead of the 1 million acres thought purchased, and it was noncontiguous land, making communal living impossible. Poor organization, unfavorable climate and disease made the Texas experiment a disaster. Ten Icarians died from malaria. In the spring of 1849, the Icarians decided to try again. Three Icarians were sent north, up the Mississippi River, to look for a new home. In Illinois, they found Nauvoo, a well-developed but virtually empty city that the Mormons had abandoned.

The Icarians purchased twelve acres of land in Nauvoo from 5 Mormon men acting as real estate agents; they had remained to liquidate church assets while the majority of Mormons fled west. On March 1, 1849, the Icarians—142 men, 74 women and 64 children—left New Orleans and headed upriver toward Nauvoo. During the voyage, 20 died of cholera. When they arrived at Nauvoo two weeks later, the colonists had ₣46,000 ($12,000), but after buying land and houses, the Mormon temple square, furniture, horses and farming implements, only ₣5,000 ($1,300) remained. Much of the surrounding land was already occupied and selling at prices too high to be purchased by the colony. Other tracts of land were rented out and too small to justify purchase.[6]

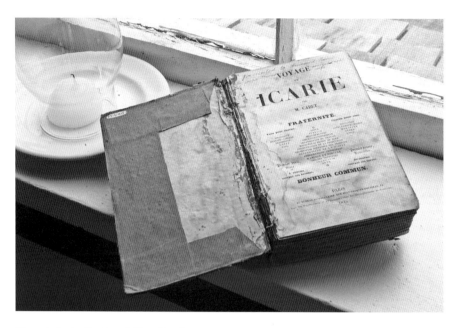

Voyage to Icaria. Courtesy of Glenn Cuerden.

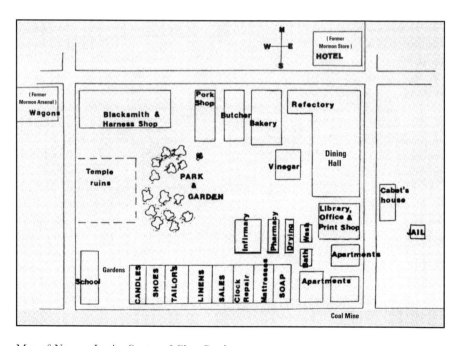

Map of Nauvoo Icaria. *Courtesy of Glenn Cuerden.*

Despite this, by April they had organized themselves into an "Icarian Community" based on the communal rules put forth in Cabet's book. Cabet was elected president for one year by the unanimous vote of the men in the community. Cabet governed with a cabinet of four elected ministers who supervised finance, agriculture, workshops and education. Since these ministers were under Cabet's supervision, he retained ultimate control unless challenged by strong opposition from the community.

Families were given rooms with a modest amount of furniture in community apartment buildings called phalansteries. They were also allowed a small garden where they could grow whatever they wished. Every family had a white pine bed, one wooden chair and table, a shelf, a small heating stove, a broom, a bucket and a chandelier for lighting. For clothing, Cabet originally considered a community uniform but thought better of it due to the magnitude of the sewing project required. Most men wore white shirts and blue slacks, while the women wore blue cotton dresses or blue skirts and white blouses. The children dressed in denim. Everyone wore straw hats in the summer and fur hats in the winter.

The community had three schools: one for boys aged six to sixteen, another for girls of the same age and a nursery school for children between the ages of three and five. Subjects taught included English, French, mathematics, drawing, history and geography. In addition, the girls were taught traditional homemaking skills, and the boys learned farming and trades. Children were wards of the community and lived apart from their parents in schoolhouses. On Sundays, however, the children were permitted to visit with their families, and they could see them during school recreation periods any other days of the week. During the week, the children were cared for by teachers, who taught them the basic message of the community: to love all persons through goodwill and develop a special love for the Community, like the special love one has for parents and other relatives.[7]

Celibacy was an offense against the community, and marriage was a duty. Divorce was allowed, but almost immediate remarriage was expected.

Everyone ate all meals together in a dining hall called the refractory, built in 1850 for a capacity of 1,200 people; there were 120 tables for 10. Meals were served three times a day, buffet style, delivered up from the basement on a conveyor belt. Breakfast was usually bread with bean or potato soup or some meat, along with whiskey and café au lait. Lunch was served at 1:00 p.m. and consisted of some type of meat or fish, potatoes, beans, corn and a leafy green vegetable. Beer, wine, whiskey, coffee or tea were the beverages served with lunch and dinner. Dinner consisted of a beef or onion stew.

Icarian apartments. *Courtesy of Glenn Cuerden.*

Icarian dining hall, Nauvoo. *Courtesy of Glenn Cuerden.*

Private property was forbidden. Every adult was assigned a job in the fields or at a workshop. All work was divided by gender. Men worked as farmers, tailors, masons, wheelwrights, shoemakers, mechanics, blacksmiths, carpenters, tanners and butchers. Women worked as cooks, seamstresses, washerwomen or ironers. Cabet assigned all tasks in the workshops and directed all agricultural activities. Workshops focused on tailoring, shoemaking, blacksmithing and carpentry. By the mid-1850s, the community had a butchery, a bakery, a flour mill, a sawmill and a whiskey distillery.

The Icarians sold a lot of their whiskey to locals and citizens of nearby towns as well, for a nice profit. During lunch and dinner and between meals, allotments of whiskey were given to all adults. On the hottest days of summer, the whiskey was diluted with water. Coming from France, where wine is a staple, they planted their own vineyards and fermented great quantities of wine, which they stored in wine cellars. Their wine was shipped to all parts of the country. Tobacco use was prohibited.

On Saturdays, the entire colony met in a general assembly to discuss community affairs and problems. Universal male suffrage was the rule, but women were not allowed to vote. However, women were given the right to speak at the assemblies. There was no compulsory denominational religion, but meetings were held on Sundays to talk about ethical and moral issues. To join the colony, one was required to adopt "true Christianity, and for a creed the practice of fraternity." In Icaria, Cabet explained, "We neither believe in superstitions or ceremonies, and those who believe that it is absolutely necessary to deceive, to brutify, and to fantasize the people in order to govern them must find very difficult the Icarian undertaking which has no other weapons other than reason and truth. But Icarians, how can you hesitate, to adopt for your religion the evangelical doctrine of fraternity, and for your creed the practice of that same fraternity?"[8]

In Icaria, cultural pursuits were the second-highest priority after education. Artistic and literary opportunities in the colony included a thirty-nine-piece symphony orchestra, a public library containing more than four thousand volumes (then the largest library in the state), the publishing of several weekly French- and English-language newspapers and one biweekly newspaper called the *Colonie Icarienne* and a theater with ongoing plays. There was also a community choir that, according to its director, was in such demand to perform at public events around the state that it once received the enormous sum of $100 to sing at a railway dedication.

The colony was also fortunate enough to have a physician, a surgeon, a pharmacy and a small hospital. Midwives delivered babies. Women and girls

bathed in a small pond by the girls' schoolhouse. Men and boys bathed in the Mississippi River.

Cabet considered expanding the Icarian Community by moving most of the colonists at Nauvoo to Adair County, Iowa, two hundred miles to the west. Some of the colonists would stay at Nauvoo, serving in a welcoming center for newly recruited Icarians that would also function as the education center for Icarian children. However, in 1851, a turning point in the colony's history occurred when Cabet returned to Paris to face charges of fraud related to the failed Texas expedition. He was found not guilty by a French court on July 19, 1851.

When Cabet returned to Nauvoo on July 20, 1852, he found the colonists were no longer following the rules, with the men now using tobacco and abusing alcohol and the women wearing fancy dresses and jewelry. Communal work had decreased, and families began to claim land as their own private property. Cabet saw his dreams disappearing and acted by imposing authoritarian rule based on his set of "Forty-Eight Rules of Conduct," issued on November 23, 1853. He verbally attacked many of the colonists and was described as acting petty, vain, authoritarian and emotionally unstable, vacillating between extreme periods of coldness and fits of rage.

By 1855, the colony had 526 members, with a small group of 57 living across the river at Montrose, Iowa, and was economically failing. The fields and workshops never again produced enough to sustain the colonists. The Icarians barely made ends meet with the money brought in by new members and subsidies sent from the home office of Le Populaire in Paris, France.

In the spring of 1855, Cabet tried to change the colony's constitution and make himself president for life. The general assembly opposed the amendment by a decisive majority. Cabet, never anticipating a resistance to his authority, was furious. The assembly followed up by relieving Cabet of the presidency. Cabet's followers decided to protest by going on strike and refusing to work. The majority—or "Dissidents," as they called themselves—banned the "Cabetistes" (the supporters of Cabet) from the dining hall. In the spring of 1856, the Cabetistes paraded to the dining hall and begged for food. The Dissidents felt sorry for their brethren and let them in to dine. Ungrateful, the Cabetistes cursed and shouted and marched in front of the building waving poles topped with food.

After a summer of discontent, the Dissidents voted to banish the Cabetistes; 180 supporters of Cabet left Nauvoo in three different groups. Two groups left on October 15 and 22, 1856, and Cabet left with the final group on

October 30, 1856. They settled in New Bremen, the German section of St. Louis. A few days after the move, on November 8, 1856, Cabet died of a stroke. On February 15, 1858, 151 Icarians settled in Cheltenham, another area of St. Louis. The Cheltenham colony continued for several years under the leadership of a young lawyer named Mercadier, Cabet's designated successor. However, political dissension over questions of leadership arose again, and in 1864, the St. Louis colony disbanded.

Meanwhile, at the Nauvoo Icaria, crops failed and financial support from Paris stopped. The national economic Panic of 1857 sealed the fate of the colony, and between 1858 and 1860, the Nauvoo Icarians relocated to Corning, Iowa, eighty miles southwest of Des Moines.

For twenty years, the Corning Icarians prospered, but then, in 1878, the colony again broke into two factions. This time the division was between the established Corning Icarians and newly arrived, young, idealistic socialists from France. These new arrivals finally left to establish their own Icarian community in Cloverdale, California, in 1883. This colony, called Icaria Speranza (the Icaria of Hope), lasted only four years. In 1898, the Corning Icaria disbanded, but its forty-six years of existence in Iowa made it the longest non-religious communal living experiment in American history.

In present-day Nauvoo, only a small amount of attention is paid to the Icarian history of the town. At the Nauvoo Historical Society's Weld House Museum, the Baxter-Snyder Icarian Room displays Icarian papers and artifacts. In nearby Macomb, Illinois, at Western Illinois University, the university library houses the Center for Icarian Studies, containing archival papers and the records of the Nauvoo Icarians. The center owes its origin to two WIU professors, Dr. Lilian Snyder and Dr. Robert Sutton, both writers of Icarian history. The seminal book on Cabet and the Icarians, *Les Icariens*, was written by Dr. Sutton. Many pictures and photos of Icarian and Mormon Nauvoo can be found in *Nauvoo: Images of America* by Glenn Cuerden.

There has been some small support from the Nauvoo community and Icarian scholars to erect a memorial to recognize the contributions of the Icarians in Nauvoo. However, some local residents believe that holding the Labor Day Grape Festival and the accompanying *Wedding of the Wine and Cheese*, a historical theatrical play, provides enough recognition of the Icarians. The growing of Concord grapes for wine was begun in Nauvoo during the 1830s by Father Jean George Alleman, a Catholic priest.

In 1846, John Tanner, a wagon maker and vintner from Switzerland, brought the Norton grape to Nauvoo and continued the wine industry

started by Father Alleman. Both Father Alleman and John Tanner had found the soil and climate ideal for the growing of grapes and were pleased with the quality of wine produced. The Icarians planted more grapevines and expanded the wine business. Baxter's Vineyards and Winery, started by Icarians Emile and Annette Baxter in 1857, continues to thrive, run by fifth-generation family members. It is the oldest winery in Illinois and produces well-reviewed wines made from Concord, Niagara, Catawba, Frontenac, Corot Noir, Noiret, Chambourcin and Norton grapes.

ERIC JANSSON AND THE JANSSONISTS AT BISHOP HILL, 1846–1862

In January 1846, approximately 1,200 Swedes led by Eric Jansson crossed the Atlantic and traveled to Illinois. One month later, the first group of Mormons began their journey west from Nauvoo to the Utah territory.

Both groups were traveling to escape religious persecution—one group coming to Illinois with the hope of finding religious freedom and the other leaving in sadness and disappointment after their prophet and leader was murdered and they were forced out by the state government and local neighbors alike.

Eric Jansson was born in the small village of Landberga, Sweden, on December 19, 1808. His parents were peasants, and their religious feelings were, he wrote, "like those of the indifferent mob, whose fear of God was in respect for the church with all its decorations and priests."[1]

As a child, Jansson was frail, played little with other children and was moody and unhappy. During adolescence, he became an enthusiastic and energetic teen with aspirations of reforming the Lutheran Church. In 1830, when he was twenty-two years old, an event happened that shaped his destiny. A longtime sufferer of severe rheumatism, he collapsed one day while plowing. He wrote about the event years later, saying, "I remembered what Christ did when he was on earth among people. So I prayed to Him to be made whole, and at once I was freed from my pains. At the same time I became conscious, believing firmly that God had

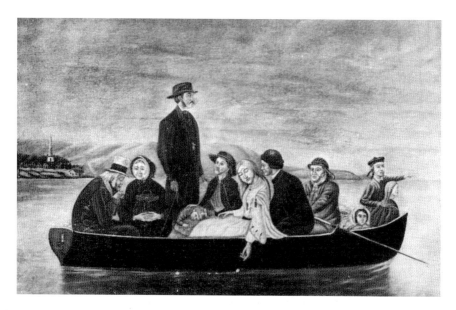

Misattributed picture of Eric Jansson (none actually exists).

taken away my sins and made me free from all sin."[2] After this healing, Jansson began an intensive study of the Bible, as well as the books of John Arndt, a German mystic.

The year 1830 was also significant to two other future Illinois communitarian leaders. For Joseph Smith Jr., it was the year the Book of Mormon was published, his church was formally organized and the Mormons left New York for Kirtland, Ohio. For Etienne Cabet, it was the year he joined the July Revolution of 1830 and wrote and published *The History of the Revolution of 1830*.

Jansson's second supernatural experience occurred ten years later while visiting a market at Uppsala. There he claims to have seen and heard the voice of Christ telling him to "take up my cross and preach my gospel to all who will listen."[3] By 1841, the parishes of Torstuna and Osterunda in the province of Vastmanland had become centers for Jansson's preaching and teaching. His interpretations of the Bible and his prayer meetings attracted much attention. He was a gifted orator, and he had an incredible memory and an abundance of self-confidence. He spoke of visions and his power to heal disease by driving out demons from the afflicted. If anyone contradicted him, he was usually able to outshout his opponent. Jansson's relationship with the state church of Sweden and its clergy was still good during this time.

J.J. Risberg, an assistant minister at the Lutheran church in the town of Ostersund, greatly influenced Jansson's spiritual development. He

encouraged Jansson in his preaching and prayer meetings and even became his co-preacher at many of them.

Soon, however, Jansson drifted away from the teachings of the Lutheran Church and began to talk against the teachings of Martin Luther and John Arndt. Jansson claimed that he was a "God sent prophet," "restorer of free doctrine" and "the vicar of Christ on earth."[4] According to Jansson, only the Bible and his own teachings and writings were to be believed and regarded as proper guidance for believers. He called on the Swedish people to accept his leadership and help him create a "New Jerusalem" in which to await the second coming of Christ and the Millennium (the thousand years following Christ's second coming).

Jansson began preaching that a true Christian is without sin and is even unable to sin: "He who is born of God cannot sin and he who sins is of the devil."[5] Because of his increasingly antagonistic attitude and preaching against the Lutheran Church and its doctrines, many of his friends and followers, including his friend Reverend Risberg, turned against him. Nevertheless, a congregation of several hundred followers remained loyal to him.

Jansson took advantage of a local tradition where farmers were allowed to meet at one of the farmer's homes for the reading and study of the Bible and prayer. These so-called Reader meetings had been prohibited by the Conventicle Edict of 1726, but during the latter half of the eighteenth century and up to the 1840s, the edict was not enforced because of a general belief in tolerance in the spirit of the Age of Enlightenment. Often, at these meetings, long letters or religious tracts written by other "Reader" groups were read, and these spread from village to village. Both the literature and the "Reader" meetings themselves became increasingly problematic for the Lutheran state church of Sweden.

In June 1844, Jansson conducted a huge burning of religious books on the shore of a lake by the town of Alta. More book burnings followed at the town of Soderala in October 1844 and at the towns of Stenbo and Forsa in December of that year. The book burnings were condemned in the Swedish press and caused a public outcry. The book burnings were the last straw, and legal action was taken.

Jansson was arrested and imprisoned but was quickly set free after a successful appeal to the king by some of Jansson's loyalists. Several months later, Jansson was arrested again and imprisoned but once again allowed to go free. Both the government and the Lutheran Church attempted to prove that Jansson was insane and needed to be locked up for the public

good. However, the king of Sweden refused to keep a man in prison for his religious beliefs, and Jansson was once again released.

During the spring and summer of 1845, violent confrontations between Janssonists and their opponents occurred in the Vastmanland and Halsingland Provinces. In October of that year, Jansson appeared voluntarily before the court at Delsbo. The court decided that Jansson should be returned to the Gavle prison and held there while an investigation continued.

Prison guard Sven Jacob Pira shared a bit of secret information with Jansson: "You will be kept in a cell together with another prisoner who has a light sentence. They have promised to release him if he can kill you in one way or another. Haven't you any friend who can help you?"[6] Jansson wrote a note to one of his followers, Pehr Pehrsson, asking for rescue.

On the way to Jansson's court appearance, outside Galve, a group of Jansson's followers, including Pehrsson and three others, laid in wait. They rushed Jansson's lone guard, pulled his coat over his head, cut the reins from his horse, bound the guard with the harness and rode away with the freed Jansson. The next day, a female follower of Jansson, who lived nearby, visited the ambush site, sprinkled it with goat's blood and spread a story that Jansson had been murdered by his kidnappers.

Jansson, disguised as a woman, left the thickly populated coastal regions of Sweden and made his way inland, where the majority of his followers lived. He remained in hiding for several months while he tried to convince his followers to immigrate to America. Believing that he had to leave Sweden, Jansson fled on skis through the mountains and forests to Christiana, Norway. There he stayed in hiding until January 1846, when, under an assumed name, he set sail for America from Oslo. J.E. Ekblom, an alderman from Torstuna, Sweden, and a Janssonist, saw Jansson just before he left for America and wrote in his journal, "He looked as though he should be taken to a mad house. There are instances of insane people, who, except for their fixed ideas, can discuss other subjects coherently and even with shrewdness."[7]

Olof Olsson, a prominent follower of Jansson's, had been sent by Jansson to America in late summer 1845 to find a suitable site for a settlement. Other Janssonist leaders were assigned to obtain funding for the trip to America. Keeping with the tradition of community ownership as practiced in early Christianity, the Janssonists sold everything they had and placed the money in a common fund, administered by the "apostles" (leaders chosen by Jansson). Jansson advocated complete communism. Anyone who left the congregation would not be able to regain what they had contributed or be compensated for

Bishop Hill Colony Visitors' Center.

Bishop Hill Colony Steeple Building.

Bishop Hill Colony store.

community work. According to Jansson, this new community would become the "New Jerusalem," and their beliefs would spread around the world.

In the summer of 1846, about 1,200 men and women between the ages of twenty-five and thirty-five left their Scandinavian homeland for America in four voyages. The number of emigrants aboard the ships and the length of time of each voyage varied. The ships carried from 50 to 150 passengers. Upon arrival in New York, most traveled west by steamship to Albany; then by canalboat to Buffalo, New York; next by propeller boat to Chicago; and, finally, by wagon or on foot to their destination of Bishop Hill, Illinois. Others took a canalboat from Chicago to Peru, Illinois, and then went by wagon to Bishop Hill. Others journeyed by wagon and/or foot directly from Chicago to Bishop Hill.

One group headed by Jonas Olson reached Bishop Hill on October 28, 1846, where two log cabins, four tents and a few dugout shelters awaited them. Two additional parties arrived shortly thereafter so that by December 1846 there were four hundred colonists. During their first winter, 1846–47, the colonists slept, separated by gender, in the eighteen- by thirty-foot dugout shelters. The dugouts contained fireplaces and bunk beds and were sheltered

in dense groves of red oak trees. These dugouts—or "mud caves," as the colonists called them—each held thirty to forty residents.

The colonists survived on hardtack and Indian corn porridge that required ten to twelve hours of cooking just to make them barely edible. The Janssonists worked from early morning until late at night, grinding bushels of corn to make enough food for basic survival. Worn out by their long journey, underfed, cold and exhausted by their work hours, ninety-six colonists died during that first winter. Others deserted the commune in order to find work and an easier life elsewhere until Jansson posted guards to prevent more from escaping.

Jansson's followers worshiped in a makeshift church that was a canvas-roofed log building, built in the shape of a cross, that could hold one thousand people. The residents of Bishop Hill awoke each morning at 5:00 a.m. to the sound of Jansson ringing a large bell calling them to worship. Armed with long sticks, church leaders would poke and prod members of the community wanting to sleep in. Feathers were brushed across the faces of sleeping children to rouse them. The daily morning candlelight service lasted for two hours, with another two-hour service held each day at dusk. Sundays required yet another two-hour service, at

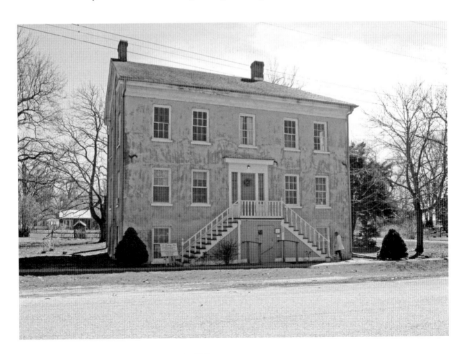

Bishop Hill Colony administration building.

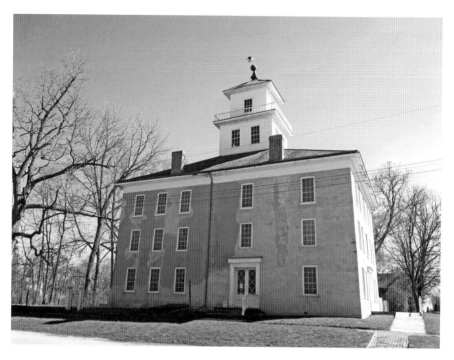

Above: Bishop Hill Colony Hotel; *below*: Bishop Hill Colony Church.

noon. After every meal, the men, in unison, said grace, and the women sang hymns.

The clothing made by the women was simple; women wore blue cotton twill on workdays and calico on Sundays, while men wore either woolen or denim pants and shirts, depending on the season. Each member of Bishop Hill received two suits of clothing and one pair of boots and shoes each year.

A school for the children was opened in one of the mud caves. At Bishop Hill, the leaders encouraged the residents to get an elementary education but go no further. Instruction in English was mandatory for all members. After just six months, Jansson preached his first sermon in English. Learning English was important for many reasons, including Jansson's desire to have English-speaking missionaries who could convert their American neighbors. Janssonist Nils Helin visited several other American communitarian colonies, successfully convincing thirty converts to move from Hopedale, Massachusetts, to Bishop Hill. A large number of Shakers from Pleasant Hill, Kentucky, also joined the Bishop Hill community. The Janssonists were taught by the Shakers how to make furniture, grow fruits and raise cattle. The residents of Bishop Hill built either adobe or cement homes. Only a few wood-frame homes were built, due to the high cost of lumber.

A fifth group of more than four hundred immigrants arrived in 1847, bringing the total population to seven hundred. Although the survivors of the first harsh winter were hopeful, the next Illinois winter of 1847–48 was even more severe, resulting in additional food shortages and illness. Two hundred Janssonists left, joined a nearby Methodist church and abandoned communal living. They had hidden some personal wealth and were able to purchase land for themselves.

In the spring of 1848, crop raising and food production were emphasized. More land was prepared for farming, and seed and farm tools were bought. By 1849, the Janssonists had acquired ten thousand acres and constructed brick living quarters and a large, three-story frame church. As the colony prospered, the colonists constructed additional buildings, such as "Big Brick," a ninety-six-room dormitory; a hotel; a wagon shop; a bakery; a blacksmith shop; a meat storage house; a brewery; an apartment house called the Steeple Building; and an administrative building. From 1847 on, the Janssonists grew both food for themselves and cash crops, planting many acres of flax, Indian brown corn and the broomcorn used to manufacture cloth, carpets and brooms. Cash from the sale of these three commodities was used to buy supplies for the community.

Above: Interior of Bishop Hill Colony Church; *below*: Bishop Hill Colony School.

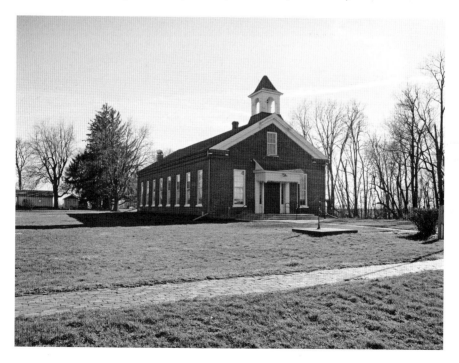

Each year, an increasing amount of cloth and carpet was made and sold; production peaked in 1857 at 150,000 yards. The market for these items declined afterward, as the Chicago, Burlington & Quincy Railroad line allowed cheaper manufactured goods from the East to flood the market. Because there were many more women than men in the colony, and because men were needed to work in the factories, women did the farm work. This included dairy work, cheesemaking, gardening and working with flax to make clothing. The colonists purchased several hundred milk cows from the Pleasant Hill Shaker community in Kentucky. They also built a four-mile railroad spur to the town of Galva, connecting to the Chicago, Burlington & Quincy Railroad track, but no line directly connected with Bishop Hill.

More groups from Sweden continued to arrive at the community until 1854, when the peak population was 1,000. The Janssonists became somewhat interested in politics but remained largely apolitical. Any immigrant was allowed to vote after living in America for just six months. On the major issue dividing the country during this time, slavery, Bishop Hill's residents were neutral. In the 1848 presidential election, Jansson backed Democrat Lewis Cass over Zachary Taylor, with 120 Janssonists marching four miles and through two feet of snow in order to vote for Cass and other Democrats. After the election of Zachary Taylor, twelve years passed before the Janssonists would become politically active again. In 1860, they voted for Abraham Lincoln and sent men to fight for the Union during the Civil War.

In 1849, one Swedish immigrant group brought Asiatic cholera to the community, resulting in the death of 150 members. Dr. Robert Foster was brought in for medical help. Unfortunately, he was an incompetent physician but a shrewd businessman and scoundrel. Dr. Foster had been living in Nauvoo with the Mormons but was exiled for committing adultery and performing abortions. Dr. Foster charged Jansson exorbitant fees for treating the cholera patients and sold him land that he owned in the area at an inflated price. Jansson gave Dr. Foster promissory notes and, as security on the notes, a mortgage on all the possessions of the community. When Jansson could not pay in full in 1849, Dr. Foster auctioned off thirty pairs of oxen, nine pairs of horses, ninety-four calves, hogs, wagons, farm tools, grain and even some bedding until the amount owed was paid. Jansson lost favor with some of the community because of this—and because of his failure to save his own wife, Maja Stina, despite his laying on of hands and praying for her to get well during the cholera outbreak.

Jansson married Anna Sophia Gabrielsson on September 16, 1849, and she raised Jansson's children, Eric Jr. and Mathilda. Jansson's ideas on

marriage evolved. His earlier study of the Bible had led him to favor celibacy. In 1847, Jansson ordered celibacy for all in the community, a decision at least partially driven by inadequate harvests and food supply. Jansson ordered periods of fasting as well. Families were permitted to live together as before, but there were to be no new babies, a decree not only unpopular but also unenforceable. In 1848, Jansson lifted the ban and commanded, "All to whom God has given a desire to marry shall forthwith be joined together or else condemned to hell."[8] Mass marriage ceremonies followed, with Jansson pairing many couples himself. Of the 102 couples married between the years of 1848 and 1853, Jansson had arranged and married 83.

The payments to Dr. Foster had come close to bankrupting the community, but the colonists still had their land and buildings. By 1850, they owned four thousand acres of land, a church, a four-story dwelling house, two other brick houses, five wood-frame buildings, a gristmill and a flour mill. Despite the cholera and desertions, there were 550 colonists left: 100 men, 250 women and 200 children.

Among the women of the community was a cousin of Eric Jansson's, Charlotta Louisa Jansson, known by everyone simply as "Lotta." Due to the death of all of her other male family members, Jansson became her guardian. In the autumn of 1848, three men—Eric Wesler, Charles Zimmerman and John Root—arrived at Bishop Hill from New Orleans. The three had traveled up the Mississippi River seeking their fortunes and looking for adventure. Charles Zimmerman left after his stay at Bishop Hill and moved to California to join the gold rush. Eric Wesler moved to Galesburg to become a successful barber and merchant.

John Root, however, stayed at Bishop Hill, mainly because he was attracted to Lotta. He told fabricated tales in which he was the son of a rich Stockholm family, a soldier in the Swedish army and had immigrated to America to fight in the Mexican-American War. He courted Lotta, and in November 1849, they were married. Jansson gave his permission after inserting a clause into their marriage contract: "Should Root ever choose to leave the colony, it is to be optional with his wife whether she accompany him or not."[9]

When the cholera outbreak struck, Root thought it prudent that he and Lotta leave, but she refused. On March 2, 1850, Root and a friend, Daniel Stanley, kidnapped Lotta and her newborn son. Twelve Janssonists from Bishop Hill raced after them. After a fight, Lotta was brought back to Bishop Hill. Root turned to the courts to recover his family. He wrote a writ for the arrest of Jansson and the twelve for restraining the liberty of his wife.

Mrs. Root was subpoenaed as a witness, but when she arrived at the local courthouse, Root had her kidnapped and brought to the home of her sister, Caroline, in Chicago. Caroline got word to a nearby cousin, Eric Jansson's brother, Jan, revealing that Lotta was staying with her. Jan rescued Lotta and her baby and brought them, willingly, back to Bishop Hill.

On March 26, 1850, the persistent Root convinced some men to recover his wife and son from Bishop Hill one more time. Root had recruited Masonic brothers from Cambridge, Illinois, where Root was a member of the lodge. After searching Bishop Hill and the surrounding area for three days, Root and his followers left empty-handed. Jansson had first hidden Lotta and the child under the floor of a cabin and then in a cave, finally fleeing to St. Louis with Lotta and her child. In St. Louis, Jansson returned to the occupation he had left behind in Sweden: a flour salesman. Letters from Jansson to supporters in Bishop Hill indicated that he was terrified for his life and concerned about the colony's finances. After the immediate threat seemed over, Jansson—along with Lotta, her child and other Janssonists who had gone with them to St. Louis—returned to Bishop Hill.

Upon his return, Jansson was notified that he was to appear as defendant in several lawsuits filed by Root at the Henry County Circuit Court in Cambridge. On May 12, 1850, Jansson preached a powerful and prophetic sermon quoting these words of scripture: "I will not drink henceforth of this fruit of the vine, until the day, I drink with you in my Father's kingdom."[10]

The next day, Jansson appeared at the courthouse. During the noon recess, the courthouse was empty except for Jansson and the court clerk, S.P. Brainard. Root ran up the stairs, entered the courtroom, exchanged words with Jansson, drew a pistol and fired twice, hitting Jansson's shoulder and his heart. The court clerk, Brainard, with a dark twist of humor, dutifully entered into the court records, "Death of the defendant strongly suggests that the case is to be continued."[11]

Jansson, like Joseph Smith, had had premonitions of his death. Smith was killed by an angry mob, and Jansson was murdered by an angry husband. Root was charged with manslaughter and convicted, serving only one year before being pardoned, and he died shortly thereafter. None of the murderers of Joseph and Hyrum Smith was ever convicted or punished.

Many citizens of Bishop Hill expected Jansson to rise on the third day after his murder. When he failed to do so, the colonists slowly reconciled themselves to his death. A city charter was granted to Bishop Hill by the Illinois legislature on January 17, 1853. Management of the colony went to the leadership of Jonas Olson, a longtime friend and follower of Jansson's,

as well as six other trustees. Bishop Hill prospered until the Panic of 1857, when Olson was found to have secretly speculated with the colony's money in railroad and bank stock that were now worthless. The financial crisis in the colony caused Bishop Hill to split into two factions. Olson made matters worse by ordering the colony members to again practice celibacy. Olson expelled those whom he learned refused to comply with his order.

Finally, in 1858, the men of the colony voted to dissolve Bishop Hill gradually between 1858 and 1862, with members of the community receiving personal shares of the community's assets. Most joined the local Methodist church, some the Pleasant Hill Shakers and the rest the Seventh-day Adventists. After the financial settlement, most stayed in the area, with both male and female members receiving equal shares: twenty-two acres of farmland, one timber lot of two acres, one town lot and an equitable amount of barns, livestock, farm implements and household goods. Some Bishop Hill residents decided to move to the nearby town of Galva.

By 1870, only two hundred Janssonists remained in Bishop Hill. One visitor to the town, Charles Nordhoff, stated that "the houses are mostly uninhabited; there are several shops, but the large buildings are out of repair and business has centered around Galva. On the whole it is a very melancholy place."[12]

In its heyday, Bishop Hill had a peak population of 1,000. In 2016, there were 104 people living there, with 20 percent of them being direct descendants of the original settlers, and 50 of the 104 residents were age forty-five or older. Most of the original, simple, Greek Revival–style buildings still stand, including the barn-shaped Colony Church (1848); the Steeple Building (1854), with its three-story clock tower; the Colony Hotel; the administration building; and the hospital. Also still standing are the bakery and brewery buildings, the schoolhouse, the cheese factory and the cemetery, with the grave site of Eric Jansson.

Other buildings have been turned into shops, restaurants and art galleries. Some of the history and lifestyle of the commune is depicted in a collection of paintings by Olaf Krans (1838–1916) located inside the Bishop Hill Museum and Visitors' Center. They show the commune's members at work doing a variety of projects, and there are some individual portraits of the leaders of the commune. To help draw visitors, the town hosts an annual Midwest Folk Festival.

The village was designated a National Historic Landmark in 1984. Much of Bishop Hill is a state historic site administered by the Illinois Historic

Preservation Agency. The agency owns and operates the Bishop Hill Museum and Visitors' Center, the Colony Church, the Colony Hotel and the village park (the site of the original dugouts). About thirty thousand tourists come to see the sites and learn the history of Bishop Hill each year. The seminal book on Bishop Hill is *Wheat Flour Messiah*, by Paul Elmen.

COMPARISONS OF SMITH, CABET AND JANSSON

Parallels exist among Smith and the Mormons at Nauvoo, Cabet and the Icarians at Nauvoo and Jansson and the Janssonists at Bishop Hill. All three men were driven by their societal visions, volatile emotions, intensity, drive and perfectionism. Smith, Cabet and Jansson hoped that their visions would change the entire world. All three men were intelligent, gifted and able to strongly express themselves. Smith and Cabet were described as being handsome, while Jansson was described as being strikingly ugly. All three were charismatic but rigid and demanding men who used power and control to gather and keep their followers.

Both Smith and Jansson believed themselves to be called personally by God and sent to restore his true doctrine. All three developed a system of missionaries or recruiters. The Mormons brought thousands to Nauvoo from England. The Janssonists converted only a few members from other communitarian societies, but the Icarians continued to bring recruits to Iowa after the death of Cabet and the failure of the Nauvoo Icaria.

Both Mormon Nauvoo and Bishop Hill were struck by disease—malaria, cholera and typhus at Nauvoo and cholera at Bishop Hill. Both communes had the misfortune of Dr. Foster preying on their communities for a time. Both Smith and Jansson advocated unusual sexual practices at times—Smith for polygamy and Jansson for celibacy and, later, mass marriages.

All three leaders were courageous and capable of enormous self-sacrifice, refusing to be deterred by early setbacks: Smith in previous settlements in Ohio and Missouri; Cabet at Icaria near present-day Dallas, Texas; and

Jansson during his years in Sweden. Both Smith and Jansson were killed after turning themselves over to legal authorities. Smith was murdered at the Carthage Jail by a militia mob, and Jansson was killed by a lone assailant in a county courtroom.

Both Jansson and Cabet had to flee their home countries, while Smith and the Mormons fled multiple states: New York, Ohio, Missouri and Illinois. All three leaders controlled the income of their followers. At Nauvoo, Smith had to deal with antagonism not only from surrounding towns and peoples but also from dissenters within. The followers of Cabet at Nauvoo and Jansson at Bishop Hill lived peacefully with their neighbors but eventually were destroyed by internal dissension.

The Mormons and Janssonists shared the beliefs of renunciation, participation and salvation. To varying degrees, members of all of the communities renounced individual wealth and property. Through participating in utopian communal living, they expected to find joy. In addition, the Mormons and Janssonists believed that by creating ideal communities and working toward their salvation, they could bring about the return of Christ and the Millennium. The Icarians attempted to create their own secular "Heaven on Earth." Despite their different approaches and histories, the three groups all failed in their communal experiments.

THEOPHILUS SWEET AND THE FOURIERISTS AT LOAMI, 1845–1848

Theophilus Sweet was born on December 16, 1785, in Pawling, New York. He briefly moved to Morgan County, Illinois, and then to nearby Lick Creek (near Loami) in Sangamon County, Illinois, as one of the first settlers in that area. The population of Sangamon County was sparse, with fewer than two people per square mile in 1820. In 1824, Sweet ran a school near Lick Creek. He was one of two ministers who organized the Spring Creek Christian Church, a few miles north of Lick Creek. In addition to being an educator and minister, he was also a very successful farmer.

By 1840, Theophilus Sweet's household was made up of eight people. He and his wife, Lucinda ("Lucy"), ages fifty-five and forty-five, respectively, lived with their children: Levi J. Sweet, twenty-nine; twins Ansel and Phoebe Sweet, fifteen; and Cyrus Sweet, thirteen; along with two hired men.[1]

Most of the early settlers of Sangamon County were from the eastern seaboard and shared many of the same attitudes and beliefs. Another early settler, Adin E. Meacham, born in Vermont, came to Lick Creek in 1819 when he was thirty years old. His wife, Isabel, was born in Massachusetts, the sister of William Colburn, another immigrant to Lick Creek from New England. Adin and Isabel's son, Adin E. Meacham Jr., was born in 1831. The Colburn family lived next to the Meachams.

William Colburn, born in 1793 in Sterling, Massachusetts, and his brother, Ebenezer, built the first gristmill and sawmill in the area. William

Loami town sign.

and his wife, Ascha, owned the first dry goods store in the area. Additionally, William was the second postmaster of the Lick Creek Post Office, from 1856 to 1869. Lucy Colburn, who was married to Levi Sweet, had been the ward of William Colburn, as she was the daughter of William Colburn's deceased brother, Isaac.[2]

Thomas and Theresa Sowell, both migrants from Virginia, also lived in the Lick Creek area in 1840. Thomas Sowell was born in Virginia in 1814 and came to Illinois in 1828. He was a barrel maker by trade and had the distinction of making "the first pork barrels in Sangamon County."[3] Sowell also owned a large farm and mill.

George and Phoebe Burr were both born in New York and became residents of the Lick Creek area. Other residents included Daniel Woodsworth, whose wife, Sally, another of William Colburn's sisters, was from Sterling, Massachusetts.[4] Born in 1791, Daniel Woodsworth probably migrated to Illinois with the Colburns in the early 1820s.[5]

By 1844, Lick Creek remained a very rural area with only six people per square mile. These early Lick Creek settlers from the eastern seaboard were the ones who were attracted to communalism—more specifically to

Fourierism. The founder of this belief system was Charles Fourier, born in Besancon, France, in 1772. He was well educated and, upon the death of his parents, came into a major inheritance. While fleeing the country during the French Revolution, he lost his fortune and barely escaped with his life.

In 1801, his first book, *Les Quatres Movements*, was published. It contained all of his theoretical work but attracted little initial attention. He proclaimed a new discovery: the principle of "Passional Attraction." According to Fourier, this is the force implanted by God in man that impels or attracts him to external objects, relations, principles and functions toward which the Passions—the particular forces of the soul—tend and in which they find their gratification. It is the active principle, the original motor power in man existing prior to reflection, and persistent in its demands despite the opposition of conventional theories of right and wrong, or moral precepts, of laws and customs or reigning prejudices.

Coming from God, it is the interpreter of his will and the oracle of his decrees. In its collective action, it impels man to fulfill his destiny on earth. In a general sense, Passional Attraction may be defined as the power that governs the moral or spiritual world as gravitation is in the power that governs the material world; one governs the movement of intelligent beings, and the other governs the movement of material bodies.[6]

This book was later rewritten into the several volumes that constituted the *Traite de L'Unite Universelle*. Fourier said, "They say that God made the world in six days, and it must be so, for there remains yet so much to be done." He went on, "And in truth there seems to be so much that is incomplete in the world as we find it, much in the conditions surrounding human beings in their present state of society that calls for explanation. Why are the factors which go to secure the happiness of the most favored individual so inadequate, and why do they reach, even imperfectly, so few of the great numbers of the earth's inhabitants?"

Victor Prosper Considerant (1808–1893)—a contemporary utopian socialist, musician and writer—read Fourier's book and, through his own lectures and followers, made Fourier's theories known to a wider audience between 1832 and 1845. Considerant also wrote *The Democracy Manifesto*, which preceded by five years the similar *Communist Manifesto* by Marx and Engels.

Fourier considered himself more important than Sir Isaac Newton. Newton had discovered the laws of attraction for the physical universe, but Fourier had found the pathways to human happiness. As harmony exists among the planets and heavenly bodies, he believed so, too, can harmony

exist among the peoples of earth. What interfered with this harmony were the foolish restrictions put on the relations between men and women with one another, which in turn brought about a false idea of their social status.

His definition of happiness was appealing. "Happiness," he said, "consists in the possession of a vast number of 'desires or passions' combined with a full opportunity of satisfying them all." Fourier divided what he thought were the twelve common passions into three categories. Combining the twelve passions resulted in 810 types of personalities, so the ideal phalanx (community) would have exactly 1,620 people, half men and half women, each pair having and representing one of the 810 personality types.

One category of passions he called sensuous, those through which we obtain gratification through the five senses. Another category was the moral affections, which include love, friendship, paternity and ambition. Finally, there are the desires of the mind and intellect. Fourier believed that these passions, if left unrestrained, would act harmoniously and would furnish their own corrections. There could be no excesses.

Fourier's ideas about social reconstruction were more democratic than those of two other prominent utopian thinkers: Henri de St. Simon and Robert Owen. The Welshman Owen (1771–1858) argued that government could make people happy, clean and industrious by strengthening paternalism (the practice of those in authority restricting the freedom of subordinates, supposedly with their best interests and welfare in mind) through complete control of their lives and surroundings. Owen started his own communities of New Lanark in Lanarkshire, Scotland, and New Harmony in Posey County, Indiana.

The Frenchman Henri de St. Simon (1760–1825) advocated that the world should be ruled for its own good by industrialists and technical specialists. He believed that such an arrangement would lead to a community characterized by cooperation and technological progress that would eventually eliminate poverty in the lower classes.

Fourier, on the other hand, wished to provide a more democratic mingling of all classes in huge apartment buildings capable of containing an ideal phalanx, also called an "association," of 1,620 people. Families were to occupy individual apartments as large or as small as needed. They were to be heated at the common expense, and there was to be a communal kitchen and laundry in each building. Fourier believed that phalanx members would live and work together, free from government interference. He hoped that someday there would be 6 million phalanxes loosely ruled by a world "omniarch," or a World Congress of Phalanxes.

Fourier, to some extent, anticipated a future with urban cities comprising large apartment buildings where the drudgery of each household could be eliminated through common resources in much the same way it actually is done today.

However, he did not believe in the equality of all men, with respect to individual talents or material possessions. Some would possess more than others, but he expected that living in close contact in the buildings would give rise to a shared sense of community. Differences would be small and cause little envy, jealousy or resentment. Fourier wanted every member of an association to receive a minimum amount of resources to clothe and feed himself, but the remainder of the income generated by the association was to be distributed in the proportions of five-twelfths to labor, four-twelfths to capital investment and three-twelfths to individual talent.

Fourier was an early supporter of women's rights, credited with originating the word *feminism* in 1837. Fourier believed that all jobs should be open to women on the basis of skill and aptitude. He saw women as individuals and not just the spouses of men. Fourier believed that traditional marriage damaged women's human rights and, in protest, never married.

He thought that both women and men had wide ranges of sexual needs and preferences that might change throughout their lifetime. He proposed, therefore, that all sexual expressions should be enjoyed, as long as people were not abused. Affirming one's difference could actually enhance social integration, Fourier believed, accepting the possibility of same-sex preference long before the word *homosexual* was ever used. He also considered the possibility of androgyny, where, regardless of gender or sexual preference, a person has an equal mix of male and female personality traits.

Long before today's online dating and matchmaking sites, Fourier envisioned members of an association and visitors alike consulting a card index of personality types and matching members of an association to find suitable partners and, if agreeable, for casual sex.

Regarding education, Fourier believed that children had tremendous potential and drive. According to him, the common characteristics of children included: curiosity, the inclination to handle everything, examine everything and learn; "industrial commotion," desiring and thriving in noisy environments; aping and imitating adults and other children as a way to learn; creating miniature homes and workplaces through their play (an early understanding that a child's play is their work, a concept that was a forerunner to play psychotherapy); and an innate attraction of the weak to follow and be led by the stronger children and adults.

Like many of the time, Fourier was prejudiced against Jews. He believed that "trade" (banking, the charging of interest and finance) was the "source of all evil." He saw the Jews' involvement in such enterprises as dangerous and thought that any Jews joining the associations should be put to work on farms. Further, he worried about global climate change and thought that at some point the seas would lose their salinity and turn acidic and that temperatures at the North Pole would become milder than in the countries on the Mediterranean Sea.

How did the ideas of Fourierism migrate to the United States? In the year 1832, a wealthy young American, Albert Brisbane (1809–1890), from the village of Batavia in western New York, moved to Paris to study with Victor Cousin (1792–1867), a French philosopher best known for helping to reorganize the French primary school system. Cousin also established the study of philosophy as a major intellectual pursuit of the French secondary and higher education schools. Afterward, he studied in Berlin with Hegel (1770–1831), a well-known German philosopher and major figure in the German Idealism movement. After studying in eastern Europe for three years, Brisbane returned to Paris with the sole intent of studying with Fourier. He quickly befriended Fourier and spent time with the circle of Fourierists, who were then publishing a weekly paper called *La Reforme Industrielle*.

Brisbane was known for being an impulsive, generous man, filled with an outpouring of love for all mankind. When he returned home to New York, he devoted himself to spreading the ideas of Fourier. The newspaper reporter Horace Greeley was attracting public attention through his writings in the *New York Times*. Brisbane paid for the use of a column in the paper to write about Fourierism. Greeley was taken with Fourierism and himself became a zealous advocate of the principles of "association," giving both his time and money to many Fourierist undertakings.

New York became the center for Fourierism and the *New York Times* its voice. Fourierist communities, phalanxes, were organized in seven states: New York, Pennsylvania, Virginia, Ohio, Michigan, Wisconsin and Illinois. Most of them were short-lived and proved an economic loss for their investors. The exceptions were the Wisconsin Phalanx in Ceresco, Wisconsin, from 1844 to 1851 and the North American Phalanx in Monmouth County, New Jersey, from 1843 to 1855.

Four phalanxes were started in Illinois, all but one short-lived. These included one in Bureau County near Princeton, a second at Greenville in Bond County and another in Canton in Fulton County. The previously

described Sangamon County Association near Loami lasted three years, the longest of any of the four Illinois Fourierist communities.

All that is known of the Bureau County group is that it was formed in 1843 and ended the same year. In 1844, the Greenville Phalanx was formed with $15,000 in stocks, land, animals and cash, "with the goal of improving the physical, intellectual, social and moral condition of society."[7] However, a site for the phalanx was never chosen, and its buildings were never constructed. In 1845, a phalanx near Canton failed almost immediately.

Why were the residents of Lick Creek who started the Sangamon County Association interested in creating their own Fourierist utopia? Carl J. Guarneri, in his book *The Utopian Alternative: Fourierism in the 19th Century*, credits this increase in Fourierism in America to the interest in the maturing Whig Party, the economic Panic of 1837, the emergence of the philosophy of transcendentalism, the spread of evangelism and the growing importance of abolitionism. Were these the same factors that drew the residents of Lick Creek to Fourierism as well?

Guarneri argued that the Whig Party's progressive social measures and conservative economic goals agreed with the Fourierists' assertion that working families living in phalanxes was a complement to capitalism, not a substitute for it. Although Guarneri admitted that at the national level there was no correlation between Fourierism and one's personal political affiliation, he believed that the Whig platform reinforced many Fourierist beliefs. The Lick Creek Fourierists who were very loyal and active Whigs held the same beliefs.

The national Panic of 1837, which came on the heels of a commercial and industrial boom and widespread economic speculation, led to an economic depression that lasted throughout the 1840s. Pooling resources and creating one's own markets in a cooperative became an attractive alternative to many laborers, artisans and farmers who were hard hit by the economic downturn. Although seventy residents of Sangamon County declared bankruptcy during the sole year that Congress allowed it, none of the Lick Creek residents did so, maintaining enough financial stability to get through the recession. For example, Andrew Heredith, an early resident of the Lick Creek area, built a sawmill in 1836, the same year that William Colburn built his. Heredith was forced out of business as a result of the Panic. Even though William Colburn's mill burned down three times between 1836 and 1873, he was financially stable enough to rebuild it each time.[8]

There is no evidence that the Lick Creek residents were interested in or motivated by either abolitionism or transcendentalism; however, evangelicalism may have had some influence. As Guarneri stated, evangelicalism as a national movement had no correlation with Fourierism, with some Fourierists being evangelicals and others Unitarians, Universalists or Quakers.[9]

However, the Lick Creek Fourierists belonged to the Christian Church, also called the Campbellite Church, and believed that the reunion of Christians in a universal church would bring about the Millennium and the return of Christ. Theophilus Sweet came to Illinois as an "Old School Baptist" preacher but then converted to the Christian Church.[10] Theophilus and his son, Levi, became Christian Church ministers at Lick Creek. Adin E. Meacham's wife, Isabel, was a member of the Christian Church, along with Daniel Woodworth's wife, Sally. The connection to the Christian Church may well have been one of the major contributing factors encouraging others to join the commune.

Other obvious contributing factors were that many of the families had known one another before moving to Illinois; many families were connected by marriage and/or had come from the same towns or areas in New England. In the winter of 1844–45, Theophilus Sweet and his son, Ansel, organized a series of lectures at Lick Creek on the "Science of Social Unity" (Fourierism).[11]

In March 1845, Theophilus and Ansel Sweet organized a Fourierist society and named it the Sangamon Association. Ansel was elected secretary of the association and wrote a notice to the *Sangamo Journal* newspaper on March 10, 1845, informing readers of their efforts to establish a Fourierist phalanx at Lick Creek. Ansel Sweet stated, "The Association will commence their buildings and other improvements this present season, and arrangements are now being made to employ all who can engage in the work." He also stated that they were collecting stock, in the form of capital and land, in the hopes of building "a model association."[12]

About the same time the Sangamon Association began, John S. Williams of Cincinnati, Ohio, and others organized the "Integral Phalanx." Williams was regarded as one of the biggest proponents of Fourierism in the West. The Integral Phalanx would buy nine hundred acres of land in the vicinity of Middletown, Ohio, about twenty-three miles north of Cincinnati on the Miami Canal, known as Manchester Mills, with $25,000 of the phalanx's capital stock and $20,000 in cash. Land owned by Abner Enoch was on the south bank of the Miami River and included a large flour mill, sawmill, lathe factory and shingle cutter factory, all powered by water.

Adapting Fourier's general plan, the phalanx would operate under a system of Pledges and Rules, the contract signed by all members of the association for managing what was essentially a joint-stock corporation. Members could cede land or money to the trustees of the phalanx or pledge to provide labor and services. Once the assessment of the value of the land or labor was made, a member could purchase shares of stock of equal value in the phalanx. These transactions were recorded so that a member would receive compensation for any labor and services over and above the cost of room and board.

The Pledges and Rules provided set rates for labor compensation and established the value of different types of land. The Pledges and Rules thus composed the legal basis for the administration of a phalanx; without it, an association was neither a true Fourierist community nor was the relationship between the phalanx and a member legally binding. Mr. Williams drew up a list, nine pages long, of five pledges and thirty-two rules for those willing to join the group.[13] Examples of two of the five pledges follow:

- Pledge 1: "Having great confidence in the practical doctrines of Associated Industry as taught by Charles Fourier of France, and having a desire to see them tested agreeably to the laws of universal analogy maintained by him, we, for that purpose, pledge and promise to pay, advance, or lend the amount of money and capital by us hereto severally subscribed to John S. Williams, Joseph Williams and Matthew Westervelt, trustees, and their appointed or elected successors, and their associates acting under the name and style of the Integral Phalanx."

- Pledge 2: "We have designated ourselves as said Phalanx in our subscription hereto, pledge and promise, to the above named persons and to each other, that unless prevented by circumstances above our control, to enter said Phalanx, with all the individuals in like manner designate as members, or may be substituted for them or added to them, as soon as proper preparations for its organization shall be made, if within three and one-half years from this time, and, also that we will remain in it at least three and one-half years, so that the system may have a fair test, for which we feel an ardent desire, under the firm conviction of the benefits of Association and of the detriments of civilization."

Examples of rules included that each member was to possess at least one share of the value of $100, contributed in money, land or credits for labor performed or materials furnished. Also, the phalanx was not to be organized until there were sixty-four families or about four hundred persons of all ages and both sexes—and not to have an inceptive existence (living all under the same roof) until the requisite number was met.

Great precautions were taken to maintain harmony among the members. When the time came to select the land and building for the phalanx, every member was to have the privilege of viewing it and then voting on it. Once a choice was made, any dissenters were released from their pledges and their credits refunded, if desired. Rules could not be altered without a month's notice and a vote of eleven-twelfths of those present. Again, if any of the minority wished, they could be released. Rule 30 read, "Excepting the pledges of experiment every denizen of the Phalanx shall at all times have the liberty to withdraw himself or herself from membership, and withdraw his or her stock. The pledges and rules of which were signed in Ohio on October 16, 1844."[14]

The members of the phalanx thought they were ready for the settlement of the Manchester Mills property, but numerous problems arose and the purchase failed. The leaders then looked for a new location, first visiting Greenville, Illinois, in Bond County. They called a meeting to be held sometime in September 1845 to decide on joining the members of that phalanx. However, members of the Sangamon Association at Lick Creek had learned of John Williams's visit to Bond County. In late September, President Dickey Anderson, Secretary Ansel W. Sweet and Treasurer Thomas Sowell of the Sangamon Association traveled the sixty miles to Greenville to meet with the members of the Integral Phalanx of Ohio. On October 16, 1845, the Sangamon Association merged with the Integral Phalanx. The combined groups contained twenty families with a total of thirty-two men, twenty-one women and forty-two children.

Why did the Sangamon Association merge with the Integral Phalanx? The Sangamon Association had 508 acres of land and was successful to a point, but it lacked enough people to sustain a Fourierist community. According to Thomas Sowell, Ansel Sweet told him that the Sangamon Association must break up if they could not get help (more members) from some source.[15] Integral Phalanx members agreed that if land could be obtained for their members they would move from Ohio to Illinois. Williams himself purchased 310 acres of land and donated it to the Sangamon Association for the merger.

After the move to Illinois, the members of the phalanx constructed buildings, harvested crops, tended to sheep and cattle and conducted the daily business of cooking, cleaning and washing. By February 1846, they were planning to "burn one hundred or two hundred thousand bricks, and erect the necessary buildings" in order for all the members to live in community. The first building was 72 feet long and 16 feet wide (it was intended to be 132 feet in length and contain a schoolroom, dining room, kitchen, printing office, secretary's office, pantry, dairy, cheese room, cellar, wood house and washroom).[16] By February 1846, the existing structure had been divided by partitions, with each family receiving two or three rooms. The space allotted for each family seems to have been sufficient for their needs. They were also planning the construction of another building by the fall of 1846. The Ohio members adjusted well to living with the Sangamon group, except that the Sangamon group wanted to progress into full-scale Fourierism, while the Ohio group thought they should wait until the phalanx had attracted the Fourierist minimum number of four hundred families. John Williams thought that full conversion and attainment of a functional "association" could take as long as twenty-five years. Other adjustments by the Sangamon Association members to the socialist economic practice also became a roadblock.

There were other reasons why the merger happened. Theophilus and Ansel Sweet believed that they could not create Pledges and Rules on their own. Had the sixty-six members of the Sangamon Association known that no additional members (only the original group of the Integral Phalanx in Ohio would come) and no additional money from this group would be forthcoming, they might have tried to simply purchase the Pledges and Rules of the Ohio Integral Phalanx. They also believed they would get the leadership and good management skills of John Williams.

However, this was not to be so. The characteristics of the Sangamon County Fourierists that gave them advantages also caused the new combined phalanx to fail. The Sangamon County residents' closeness—and, in many cases, their family ties—made their decision to join the Integral Phalanx easy. Julia Dawson stated, "When the Integral Phalanx was organized with so many of our friends we felt no hesitancy in joining....Father was willing to cast his lot with all of his possessions in this venture."[17] However, this intimacy may have also led to their eventual dislike of John Williams. A woman who was fourteen when her family lived with the Integral Phalanx stated in 1907, "Williams did not stay long because he was not liked by the people. In fact, there was only one person I was disliking and that was Mr. Williams."[18]

The Sangamon Association residents' economic independence and middle-class status was another cause for the demise of the phalanx. The families had been doing well on their own; their land was productive, their livestock were healthy and the children were well fed. Families who were accustomed to plentiful harvests did not like sharing their bounty with others for a purely philosophical reason. For example, Julia Dawson remembered not having as much milk as her family had been used to before: "Seldom could we have more than a quart, now, in spite our cow, the milkers told me, was the best of the milking cows."[19] Another member recalled losing free access to her father's orchard: "When summer came with time for garden and fruit, it was a hard time for us....There were pa's cherries and other fruit that we were not allowed to touch....We had to see the fruit divided getting scarcely a taste of what otherwise would have been ours in the greatest abundance."[20]

Disagreement continued to develop over questions of food supply and whether the president should conduct phalanx business in the open or in secret. "It was too much of a one sided affair," recalled one member of the phalanx. "Men came there with large families, no property, very little money, and in some instances none at all and were getting a living at the expense of the old farmers who had invested all they had in the Phalanx."[21]

President Williams resigned in April 1846, and William G. Pearse was elected as his replacement. But after Williams's departure, families began to obtain legal advice on how to dissolve the colony. In April 1848, after a lengthy controversy over who owned the land, all of the property was transferred to the original owners and the phalanx was dissolved.

The phalanx failed because the merger under Fourierist practices could not continue to provide the Sangamon County Fourierists the benefits they had enjoyed before. When asked, "Seen the circumstances and influences that operated in the Phalanx, as you now see things, would you have entered it?" Ascha Colburn answered, "I think not."[22] From their point of view, any advantages of life in the phalanx were not worth the trouble caused by it.

Perhaps it is best summed up by George E. Dawson, a son of one of its members, who lamented "that despite all the devotion and effort at harmonizing, conflicting human interest in a communal social structure, in the end, in such communities did not change the nature of men themselves and cannot remove the controlling force of self interest."[23]

Loami in 2016 had a population of 749, with 30 percent of the population being forty-four or older. Most current residents work in the nearby towns

of Springfield or Jacksonville. No tourists come to visit, and no markers or museums recognizing the existence of the Sangamon Association/Integral Phalanx are to be found. The seminal work on the commune is *Utopian Socialism in Sangamon County: The Story of the Sangamon County Association and the Integral Phalanx* by Kelly Boston.

GEORGE PULLMAN AND HIS EMPLOYEES AT PULLMAN, 1881–1899

George Mortimer Pullman, president of Pullman's Palace Car Company, hoped to create a utopian industrial town. George was the third of ten children born to James and Emily Pullman. He was born on March 3, 1831, in Brocton, New York, but his parents soon moved to Portland, New York. The family moved to Albion, New York, in 1845 so that Pullman's father, who was a carpenter by trade, could work on the construction of the Erie Canal. His specialty was moving structures out of the way of the canal with jackscrews and a device that James patented in 1841. George attended public schools until age fourteen, when his father died in 1855. George took over the family business, winning a contract with the State of New York the next year to move twenty buildings out of the way of the Erie Canal. In 1857, George opened a similar business in Chicago, where help was needed in raising buildings above the Lake Michigan floodplain to allow the installation of a new modern sewage system for the growing city.

Pullman's company was one of several employed to lift multistoried buildings, as well as whole city blocks, a total of four to six feet. Pullman realized that leaders in other cities, after learning of Chicago's problems, would want their newly erected buildings to have better foundations beneath them.

Possessing the entrepreneurial spirit of his father, Pullman decided that another good business venture would be the manufacture and leasing

Left: George Pullman. *Courtesy of Frank Beberdick and the Historic Pullman Foundation.*

Below: Greenstone Church, Pullman. *Courtesy of Frank Beberdick and the Historic Pullman Foundation.*

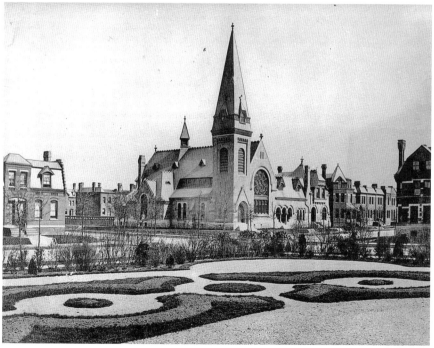

of railroad cars for the exploding American railroad system. Although companies were most interested in the transportation of raw materials and finished goods on their new railroad lines, Pullman thought that he should invest in passenger travel. As a businessman, he often rode trains and found the regular passenger cars to be uncomfortable and dirty.

Sleeping cars, which were just starting to come into existence, had cramped beds and poor ventilation. Pullman decided to build a better sleeper, one that was not merely comfortable but luxurious. He asked his friend and former New York State senator Benjamin Field to be his business partner. Pullman convinced the Chicago, Alton & St. Louis Railroad to rebuild two of its cars to his new style. The cars were an immediate success, with newspaper reviews favorably comparing them to steamship cabins and declaring them the most luxurious way to travel.[1]

When the Colorado gold rush began in 1859, Pullman realized that the real gold to be made was not in searching for it, but rather in meeting the needs of the miners. He and some other investors opened the Cold Springs Ranch in Central City, Colorado, which became the place to go for miners needing a meal, a bed and supplies. Miners also stopped there to switch out their tired teams of animals for fresh ones before heading back to the mountains, thus the ranch learning the name the "Pullman Switch."[2]

Pullman returned to Chicago. In 1861, with the outbreak of the Civil War, Pullman, like many of the wealthy men of the period, simply hired a replacement to serve for him. During the war years of 1861–65, he continued to produce even more luxurious sleepers. In 1865, his first unconverted car, the "Pioneer," was built from scratch with folding upper berths and seat cushions that could be extended to make lower berths. The Pioneer drew national attention when several of them were part of the train procession that carried the body of President Lincoln from Washington, D.C., to Springfield, Illinois, for burial.[3] Years later, when George Pullman died in 1897, President Abraham Lincoln's son, Robert Todd Lincoln, succeeded Pullman as president of the Pullman Company. Robert continued the Lincoln connection with the railroad industry, as his father had focused much of his career as an attorney in Springfield representing the many railroad companies of Illinois.

George Pullman married Harriet Sanger, daughter of a construction company owner, on June 13, 1867. They would have four children: Florence (1868–1937), Harriet (1869–1956) and twins George Jr. (1875–1901) and Walter Sanger Pullman, known as "Sanger" (1875–1905).

By the late 1860s, Pullman was hiring only African Americans to serve as porters on his Pullman cars. After the Civil War ended, Pullman knew

that freed slaves would need jobs. He was also aware that most Americans, unlike the very wealthy, did not have personal servants. Pullman intended to give the white middle class an upper-class experience of being served by black butlers, waiters and maids in his Pullman cars. At its peak in the mid-1920s, the Pullman Company employed twenty thousand black men as porters, becoming the largest employer of black men in the nation. The porters worked twenty hours a day and had to pay for their own uniforms, meals and the polish used to shine the shoes of their wealthy clientele. The Brotherhood of Sleeping Car Porters (BSCP) was a labor union organized by black men and women employees of the Pullman Company in August 1925 and was led by A. Phillip Randolph and Milton P. Webster. In 1937, the BSCP became the first black labor union to sign a collective bargaining agreement with a major U.S. corporation.

In 1867, Pullman and Field dissolved their partnership, and Pullman became the sole owner of the Pullman Palace Car Company. The company grew during the next two decades; by 1879, it had 464 cars for lease, gross earnings of $2.2 million and a net annual profit of almost $1 million.[4] The company also manufactured and sold freight, passenger, refrigerator, street and elevated cars. By the 1890s, the company was worth more than $36 million.[5]

In 1879, Pullman decided to build his own model utopian community, a place that would be superior to anyplace else the working class lived in America. By so doing, he hoped to avoid strikes, attract the most skilled workers, improve their productivity by paying them what he believed to be a fair wage, provide better health from the fresh air and clean and modern homes and prohibit saloons and houses of prostitution.[6] Pullman realized the necessity of building his town to be accessible to his factories, major city markets and railroad connections to the whole country. In 1880, Pullman hired landscape architect Solon S. Beman, building architect Nathan F. Barrett and civil engineer Benzette Williams to build his city on four thousand acres purchased for $800,000.[7] The land was adjacent to his factory near Lake Calumet, fourteen miles south of Chicago.

The town, constructed by Pullman employees, came into existence on January 1, 1881.[8] The buildings were brick, made from clay found at Lake Calumet. A brickyard was built south of town solely for the purpose of making bricks for the city's buildings. Pullman shops also produced construction materials that were used in the buildings. At completion, Pullman had 1,300 buildings, including housing for his workers and their families, shopping areas, churches, theaters, parks and a library. The centerpiece of the town

was its city hall and the nearby Hotel Florence, named after Pullman's first daughter. Each home for a worker and their family had indoor plumbing and access to gas and water. In addition, all workers and their families had access to all public facilities. Maintenance of the residences, as well as daily garbage pickup, was included in the rent charge.

The planned community was completed in 1884 and was a huge attraction during the 1893 World's Columbian Exposition in Chicago. The country's newspapers hailed George Pullman for his kindness, benevolence and vision.[9] Others thought that his real motivation was simply to increase his overall profit through a healthy and loyal workforce.

In reality, Pullman was basically a company town ruled by "King George," as some called him. He had a complex personality described in various personal accounts as humble, gregarious, generous and sentimental yet also taciturn, covetous, ill-tempered and indifferent.[10] All of the housing was owned by George and could only be rented, never privately owned. The housing reflected the social hierarchy of the workforce. Freestanding homes were for the company executives, row houses for the skilled workers or most senior workers, tenement homes for the unskilled workers and rooming houses for

Pullman Visitors' Center.

Greenstone Church, Pullman.

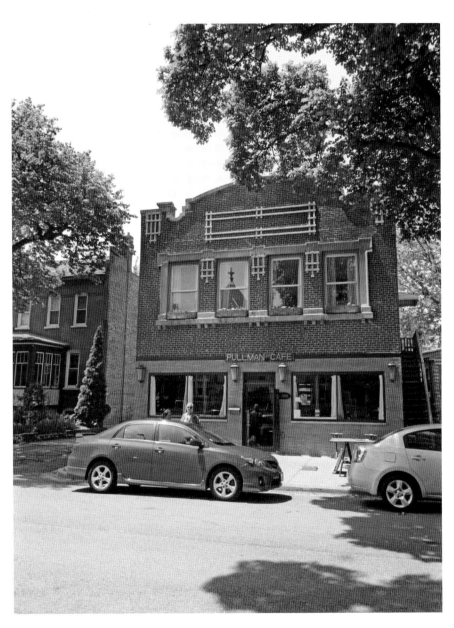

Pullman Café.

the common laborers and their families.[11] Reflective of the times, no African Americans were allowed in the town.

Pullman prohibited independent newspapers, public speeches, town meetings and open discussion of community issues among its citizens. His inspectors regularly entered homes to check for cleanliness. The company was given the authority to terminate leases upon a ten-day notice. New churches that were built in Pullman, for the most part, stood vacant because they could not afford to pay the high rent required. Only Protestant denominations were invited into Pullman.

Although workers were not forced to live in the town, they were strongly encouraged to do so. Rent was higher in areas surrounding Pullman, averaging fourteen dollars per month, but many workers chose to live outside rather than deal with the strict rules in Pullman.[12] Pullman expected to make money from both the construction and operation of the town. Each payday, he issued workers who lived in the town two checks, one made out to the Pullman Company for rent and the other to the worker for the balance of their wages. A paymaster delivered the checks with a rent collector standing nearby. Each worker was required to immediately endorse his rent check and hand it over to the rent collector.[13] By 1892, the community had become profitable for Pullman and had a valuation of more than $5 million.[14]

In 1893, there was a severe economic depression in the United States. The Panic of 1893, like the Panic of 1873, was caused by the overbuilding and speculative financing of the railroads, resulting in many bank failures and a run on the gold supply. The 1893 Panic was the worst economic depression the United States had experienced to date. In reaction, Pullman cut jobs and wages and cut working hours rather than reduce the dividends he paid to the stockholders. The Pullman workers' wages had been barely enough to live on in good times; now, even less remained after their bills were paid.

Many of the workers, driven to desperation, joined the American Railway Union (ARU). An ARU committee tried to meet with Pullman to discuss their plight, and Pullman reacted by having them all fired. On May 11, 1894, four thousand Pullman workers went on strike under their leader, Eugene V. Debs. Negotiations went nowhere, and Pullman refused arbitration. In reaction, Debs called for a boycott of all Pullman cars. Sympathy strikes by other unions in other states occurred throughout the nation. Rioting and violence broke out in Chicago, and Illinois governor John P. Altgeld, a union sympathizer, refused to call out the state militia.

On July 2, U.S. attorney general Richard Olney procured an injunction from a federal court forbidding the unions from impeding mail service and interstate commerce. Acting on Olney's advice, President Grover

Above: Pullman porter mural; *below*: Hotel Florence, Pullman.

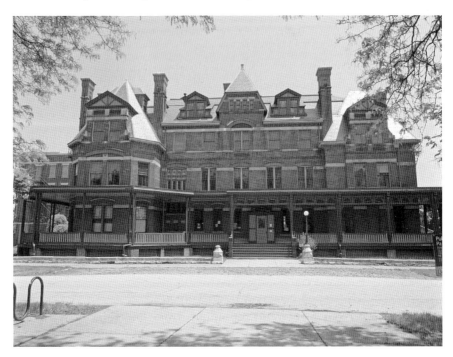

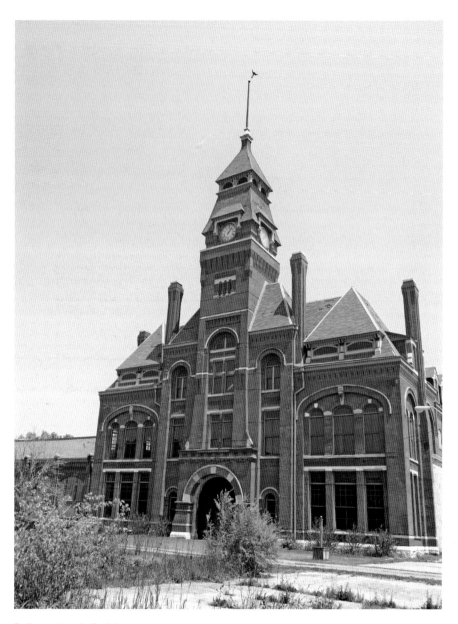

Pullman Arcade Building.

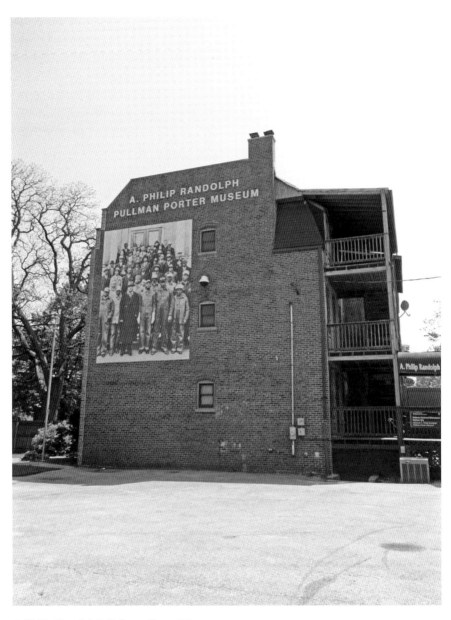

A. Philip Randolph Pullman Porter Museum.

Pullman porter uniform.

Cleveland ordered 2,500 federal troops to Chicago on July 4, 1894, to stop the strikers from blocking trains. More violence broke out in cities around the country, but the strike began to collapse. Debs was convicted of violating a court order and sentenced to prison, the ARU was dissolved and the strike ended within the week. A total of 30 strikers had been killed and 57 wounded, and property damage exceeded $80 million.

The troops were recalled on July 20. Pullman's company returned to prosperity, continuing to build sleeping cars for the nation's rail system. Pullman also headed a new company that built the Metropolitan elevated system in New York City.

The national and Illinois union movements continued to hate Pullman. After Pullman died of a heart attack in 1897, he was buried at Graceland Cemetery in Chicago in secret, at night, in a lead-lined coffin within a reinforced steel and concrete vault. Several tons of cement were then poured over the vault to prevent his body from being dug up and desecrated by union activists.

After Pullman's death, the Illinois Supreme Court required the company to sell the town because operating it was outside the company's original charter. In 1899, the town was annexed by the city of Chicago. Within ten years, the city had sold all of the rental houses to their occupants. Pullman was now just another neighborhood of Chicago.

In 1947, the Pullman Company was sold to a consortium of fifty-seven railroads for about $40 million. In 1960, the town was threatened with total demolition by developers representing an industrial park. The residents formed the Pullman Civic Organization and saved the neighborhood. Pullman became a State Landmark District in 1971 and a City of Chicago Landmark in 1972. In 1991, the State of Illinois purchased the Hotel Florence and the Pullman Factory Clock Tower and Administration Building under the supervision of the Illinois Historic Preservation Agency for the development of the Pullman State Historic Site.

Hundreds of original Pullman houses continue to undergo privately funded interior and exterior renovation and restoration. Pullman remains one of Chicago's seventy-seven neighborhoods. In 2016, the Pullman neighborhood had a population of approximately 7,200, with 62 percent over the age of thirty-eight. Annually, about 3,000 visitors visit this historic area.

In February 2014, President Barack Obama declared the Pullman District a national monument. Its boundaries are 103rd Street on the north, 115th Street on the south, Cottage Grove Avenue on the west and the Norfolk and

Western Rail Line on the east. The designated area includes the North and South Pullman neighborhoods and the Administration Building (the Clock Tower), the old factory, the Hotel Florence, Greenstone Church, the market square and hundreds of row houses.

Visitors are welcomed and educated at the Pullman State Historic Site Center and at the A. Philip Randolph Pullman Porter Museum. The most informative book about Pullman and his city is *Palace Car Prince* by Liston Leyendecker.

JOHN DOWIE AND THE DOWIETES AT ZION, 1901–1942

Another communitarian experiment in Illinois began at the turn of the century in Zion, led by John Alexander Dowie. Dowie was born on May 25, 1847, in Edinburgh, Scotland, to John Murray Dowie, a tailor and minister, and Ann Macfarlane-McHardie. Both parents were very religious. By the age of six, young Dowie had read the entire Bible and taken a pledge of temperance. Earlier that year, he had stolen his father's pipe, smoked it, became very sick and was "led to God to make the decision against using tobacco, alcohol, and opium."[1] In 1860, the family moved to Australia to work at a thriving shoe and boot business owned and operated by his paternal uncle. After the move to Australia, Dowie developed chronic indigestion. As he read his Bible, prayed and meditated, he "was brought to trust God for all healing and in answer to my prayers was completely delivered from this trouble, at the age of sixteen."[2]

Dowie worked for his uncle for a while, took various other jobs and finally became a clerk at a prosperous law firm.[3] In 1868, at the age of twenty-one, Dowie returned to Edinburgh to study theology and English. Upon receiving his degree, he returned to Australia and became an ordained pastor of a Congregational church at Alma, South Australia, in 1872. He received and accepted a call to pastor at Manly, New South Wales, in 1873 and again at Newtown in 1875.[4] During this time, he became further convinced that disease could be cured through prayer and the laying on of hands. He married his third cousin Janie Dowie on May 26, 1876, and started a family that would grow to three children: Gladstone, Jeanie and Esther.

Above: Shiloh House, Zion; *below*: *Leaves of Healing* publication, Zion.

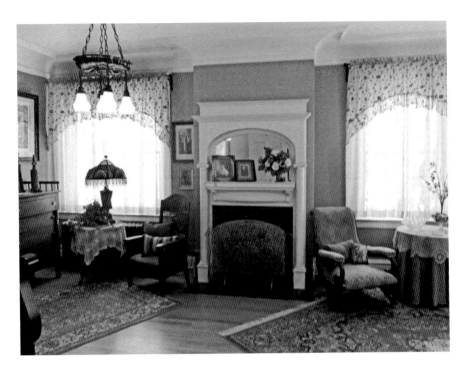

Interior of Shiloh House.

Dowie published *Rome's Polluted Springs* in 1877, based on two lectures that he had given at the Sydney Masonic Hall. In 1879, he published *The Drama, The Press, and the Pulpit*, which were also two lectures given in Sydney, in March of that year. In the same year, he resigned as a pastor of the Congregational Church to become an independent evangelist, claiming the powers of faith healer and holding his meetings in a local theater.[5] He also got involved with the Salvation Army.[6] He moved to Melbourne in 1880, and his followers continued to grow.[7] In 1882, Dowie was invited to become the pastor of the Sackville Street Tabernacle Church in Collingwood. While there, his authoritarian leadership caused a split in the church. He was arrested, jailed and fined for leading unauthorized marches, which he described in his book *Sin in the Camp*.[8]

After a suspicious arson scandal burned down his church (enabling him to pay off his creditors and debts), Dowie looked for a new start in America in 1888.[9] He settled first in San Francisco, where he built up a huge following attracted to his faith healing performances.[10] Dowie then started the International Divine Healing Association, a for-profit business. All members were expected to tithe to be eligible to receive Dowie's aid

in healing any sickness. Requests could be made by mail, telegram and, ultimately, telephone. Dowie made his living by collecting tithes, buying bankrupt companies and selling their worthless bonds to the members of the Divine Healing Association.[11] Two women whom Dowie scammed took him to court, successfully sued and won their case against him. This legal and public relations disaster prompted Dowie to move again, to Chicago, in 1890. There he first preached at the Methodist Episcopal church but was soon told to stop because of his anti-tobacco and anti-pork stance. Over the next three years, he took missionary trips to Minnesota, Maryland, Pennsylvania and Canada.

During the Chicago years, he asked others to call him "Doctor Dowie." He rented some property next to the site of the World's Fair of 1893, built a small tabernacle there called the "Little Wooden Hut" and staged "Divine Healings" in front of large crowds. The "healed" were often audience plants or carefully prescreened persons who were susceptible to his powers of persuasion and light hypnosis. Part of Dowie's power also rested in his impressive physical appearance. Dowie was five foot, four inches tall but weighed two hundred pounds and had an enormous brow, large brown eyes and an extensive beard.

One of his "healings" brought Dowie out of obscurity into the public eye. A popular attraction at the World's Fair was Buffalo Bill's Wild West Show. Bill's cousin Sadie Cody, traveling with the show, had been suffering from a severe back condition and went to see Dowie. Dowie healed her on stage; due to Buffalo Bill's popularity, Dowie became famous himself. Another notable event during that period was the healing of Miss Amanda Hicks, president of Clinton College in Clinton, Kentucky. She was brought to Chicago by train and stretcher to have Dowie heal her from a cancerous tumor and addiction to morphine. She returned to her home in Clinton entirely healed. Dowie's therapeutic and spiritual gifts were probably helpful in the curing and relieving of some psychosomatic illness, as well as those of somatic origin.

Dowie was a charismatic speaker who drew large crowds and many followers. He established several churches and "healing homes" in the Chicago area, even though he spent much of 1895 in court fighting allegations that he was practicing medicine without a license.[12] Because of his increasing popularity, he needed a larger building in which to hold his meetings. He dissolved the International Divine Healing Association, bought the Chicago Auditorium and formed the Christian Catholic Church in 1896, renamed the Christian Catholic Apostolic Church in 1903. Dowie

despised and preached against all other faiths, once saying, "It is time that the Baptist Church be utterly smashed."[13]

Dowie was a restorationist who sought to reestablish the "primitive condition" of Christ's Church. He believed in the spiritual gifts of miracles, healings and speaking in tongues and advocated a return of all the apostolic offices in the church, such as the apostles, prophets, evangelists, pastors and teachers.[14] In 1899, he called himself "God's Messenger," and in 1901, he claimed to be the returned prophet Elijah, calling himself "Elijah the Restorer," "the Prophet Elijah" and "the Third Elijah,"[15] the forerunner to Christ's second coming. In addition to strongly attacking the Baptists, he argued that Christ would destroy the Muslims upon his return.

In India, Mirza Ghulam Ahmad preached for a return to Islam in its original form and founded the Ahmadiyya Movement of Islam in 1889. Ahmad claimed to be Jesus Christ in spirit as well as the foretold Imam Madhi, who upon his return would establish the final victory of Islam on the earth. Ahmad learned of Dowie and his preachings and challenged him to a prayer duel, stipulating that the false claimant would die during the lifetime of the truthful claimant. Dowie never accepted the challenge. However, Dowie would die in March 1907, while Ahmad passed in May 1908.

Under Dowie's leadership, ministers of his church were ordained, new congregations were formed and missionaries were sent abroad. Dowie continued to preach on "salvation, healing, and holy living" and printed a weekly publication, *Leaves of Healing*, reporting on all the activities of his church. Dowie continued to draw criticism from the press and leaders of the traditional denominations. In 1895, he opened three "Divine Healing Homes." Members of the medical profession cursed him, and local public health officials harassed him by making unannounced spot checks on his "healing homes." In response, Dowie turned his homes into traditional hospitals. Now subject to licensing, the Illinois State Board of Health intervened, resulting in more than one hundred arrests of Dowie, with jail time, the posting of bonds and numerous court appearances that year. Dowie was usually found not guilty.

On one occasion, Dowie was even arrested while giving a sermon. The continuing scrutiny by the authorities made him an underdog and a martyr in the eyes of many, and this gained him even more followers. Soon, even the large Chicago Auditorium, built in 1889 and seating 3,901, could not hold all of his followers. It was there, a few minutes after midnight on January 1, 1900, that Dowie finished giving his sermon and drew back a curtain to show detailed maps and drawings of his utopia: Zion, the City of God. He

explained that it would be the "perfect community": "No tobacco, alcohol, drugs, pork, oysters, dancing, swearing, spitting, gambling, bars, houses of prostitution or dance halls would be allowed. Whores, doctors, politicians, health inspectors, assessors and tax collectors would be 'conspicuous by their absence.' Zion would provide a place, the work, and the full share of reward due to those who labored under God's plan—'Where God rules, man prospers.'"[16]

In 1899, Dowie purchased six thousand acres of land in the extreme northeast section of Illinois in Lake County, forty miles north of Chicago. He owned all of the land and property personally. He leased the land to his followers for 1,100 years, claiming that it would take that long for Zion to be protected from all abominations such as alcohol, tobacco, gambling and so on. He forced his followers to deposit their wealth into the "Zion Bank," which appeared to be a registered entity but was, in fact, unincorporated and solely under his control. Dowie sold worthless stock to anyone who would invest. Zion was later characterized by the press as "a carefully devised large platform for securities fraud requiring a significant organizational, legal and propagandist agenda and plan in order to carry it out."[17]

Dowie intended Zion to house up to 200,000 of his followers. On July 15, 1901, the gates of the City of Zion were opened. Two hundred acres were reserved in the center of the city for Shiloh Park, ten acres of which were called the Temple Site, on which, in 1902, a new church was built that could seat 8,000 people. All but two of the streets in Zion were given biblical names, to be a daily reminder for the city residents to remember and ponder the characters and events from that holy book. To care for the sick, he built the Elijah Hospice, alleged to be the largest wooden structure ever built during that period. The city provided its children with both an elementary and high school education. Construction of a college was started. A large building for housing families called the Shiloh House was completed. A fully volunteer police and fire department protected the city.

Dowie established twenty-five businesses, providing many jobs. Dowie imported an entire lace-producing plant that, at its peak, employed five thousand people. As a result, Zion achieved fame for its fine-quality lace production. He also opened a store, the Zion Department Store, which employed three thousand. Later, when the commune dissolved, the Marshall Field Company of Chicago bought the lace plant.

Dowie also brought George H. Lawrence, a world-famous commercial photographer, to Zion to take photos. In 1900, Lawrence built the world's largest camera. The camera weighed 1,400 pounds and used a 4.5- by 8-foot

glass plate negative. It took a fifteen-man crew to operate it. Lawrence was known for using kites and balloons for aerial panoramic photography. At Zion, Lawrence climbed a 75-foot tower to take his panoramic and promotional shots. In 1901, he shot Dowie consecrating land in Zion and came up with a twenty-four- by ninety-six-inch half-tone picture. From 1913 to 1921, Arthur S. Mole, also a professional photographer and resident of Zion, took "living pictures," so called because his photographs were composed of people arranged to form images. Most of his pictures depicted religious or patriotic themes.

In 1903, Dowie became a United States citizen. By then, Dowie's mismanagement had begun to affect the economics of the city. He was spending foolishly and lavishly and continued to practice fraud and mismanage the funds. Also, in 1903, he led a mission to London that failed. In 1904, he led another mission, this time to New York, taking three thousand of his followers on a religious crusade. While in New York, he erected a baptismal font in Madison Square Garden and conducted a revival. The mission trip cost $300,000 and produced few converts.

In 1906, while touring Mexico to purchase some plantations (which he wanted to call "Zions of Mexico"), Dowie suffered a stroke and became paralyzed. While still in Mexico, he was replaced as head of the church by Wilbur Glen Voliva, his chief lieutenant. Voliva and official investigators had discovered that between $2.5 and $3.4 million was unaccounted for.

Dowie attempted to regain control through litigation but failed, and until his death in 1907, he was forced to live solely on an allowance secured through a court order. Dowie was buried at Lake Mound Cemetery in Zion. One detail about his burial—whether Dowie's body was encrypted under six feet of concrete so that he could never rise from the dead—has not yet been proven to be true or false.

After Dowie died, some disenchanted members among the 7,500 residents of Zion left the Christian Catholic Church and joined the Grace Missionary Church that had formed in Zion in 1906. Those who had Pentecostal leanings joined with the Assemblies of God congregation to form another new church in 1908. New churches continued to form and organize in the years ahead. For most residents of Zion and members of the Christian Catholic Church, moving away was not possible, so they stayed.

Recognizing the importance and advantages of technology, the new leader, Voliva, established a five-thousand-watt radio station in 1922. The station, WCBD, located in Zion, aired music, sermons and messages from the Christian Catholic Church with no commercial interruptions. Heard as

far away as New Zealand, this radio station gave Zion more attention and recognition, and it was eventually sold to station WAIT in Chicago after the church's broadcasts stopped in 1934.

Voliva's hostile personality continued to drive many away from the Christian Catholic Church. From the pulpit, he preached against the evils of cigarettes, silk stockings, oysters, alcohol, immodest dress and modern science. He would often shout that there was no room in Zion for those who refused to believe that "the world was flat as a stove lid, or who succumbed to the insidious lure of the demon nicotine, or to the tinseled sham of the movies." Voliva also spoke out against astronomy, evolution and those who studied ancient religious works to better understand their world and the religious works in context. He predicted that the world would end in 1923, then in 1927, then in 1930 and then in 1935. He also predicted that he would live to be 120 because of his special diet of buttermilk and nuts. This preaching did not appeal to many members of the church, so they rebelled.[18]

Not all members of the Christian Catholic Church strictly followed the teachings of Voliva and the church. Independents (those not affiliated with any church or affiliated with a different church than the Christian Catholic Church) also rebelled against the rules of the community. Many ate pork and took up tobacco and alcohol. Some even went to doctors outside Zion. Many compliant residents knew that these things were happening but did not say anything; many friendships existed between the two sides.[19] However, there was an ongoing war of words between the leaders of each side, largely through a "Battle of Billboards."

One Independent billboard read as follows:

> *Voliva boasts that he controls Zion City. He is, therefore, responsible for its present barbarous condition—years behind the times. If so, he proves that our constitutional city charter is null and void, and that our mayor, alderman, police and judiciary are practically his appointees, receiving their orders from him and their pay from the people, nearly half of whom do not belong to Voliva's church. Today there are 44 Independent business enterprises and 12 denominational churches in this city, with room for more. Over half the taxes are paid by Independents. It is one of the best resident and business sites between Chicago and Milwaukee. Clean business enterprises are solicited. We are not fanatics here, come and see. Help us redeem and civilize this city.[20]*

Voliva's billboard responded with:

That wretched looking old dilapidated thing across the street (look at it) was placed there by a bunch of idiots and lunatics. They have pimples where they ought to have heads. They vainly imagine that they can destroy Zion. God and all of Zion's people are laughing at them. Some of the same bunch broke open the vault in the brick building across the street, mutilated the election tally sheets, attempted to steal the recent election and were kicked out into the street by a ruling of the Supreme Court of Illinois. Most of their statements are absolute lies. Their invitation is a sufficient warning to all persons (except the loyal Zion people) to keep away from this city, as a place of business and residence. This city is the private home of loyal Zion people, and outsiders, who if they had any sense would not live in a "barbarous town," a town "years behind the times," a town "ruled by Voliva"—a town where a red hot war is raging, and will continue to rage day and night until Zion's people win a final and complete victory. In conclusion—pay no attention to this bunch of traitors, they are exactly like their old board—badly cracked.[21]

As the original generation of Zion's pioneers began to die off, Voliva's control continued to wane. The number of Independents increased, while the influence of his laws and restrictions decreased. The new generation, except for a few factions, did not share the dream of utopia. On October 11, 1942, Wilbur Glen Voliva died at the age of seventy-two. By the 1940s, Zion looked very much like most midwestern American towns.

In 2016, the population of Zion was 24,339; of that number, 25 percent were forty-five or older. The Shiloh House, which was the final residence of Zion's founder, John Alexander Dowie, serves as Zion's only museum and visitors' center and is owned and operated by Zion's Historical Society. It currently houses the office of Zion's Chamber of Commerce.

The Shiloh House is a beautiful, restored three-story home and is open for guided tours from 12:00 p.m. to 3:00 p.m., Monday through Friday. Annually, about three thousand visitors come to the Shiloh House to learn about the history of Alexander Dowie and Zion. For those who want to learn more about Dowie, read *John Alexander Dowie* by Gordon Lindsay.

CHAPTER 8

COMPARISONS OF THE
SIX COMMUNITIES

L et us examine the six communities along eight dimensions: religious
versus secular, communitarian economics versus free enterprise, political
versus apolitical, legal problems versus no legal problems, immigrants versus
native-born, upper versus lower economic class, contemporary sexual
behavior versus atypical sexual behavior and internal versus external conflict.

RELIGIOUS VERSUS SECULAR. Three of the communities were founded
to follow a religious practice: the Mormons, the Janssonists and the
Dowietes. The Mormons were able to continue their religious practices
and today have a membership of more than 16 million worldwide. Upon
the dissolution of the Janssonist and Dowiete communities, their members
simply joined local churches in their respective areas. The strong religious
organization, leadership and isolation from outside interference in Deseret
for some forty years allowed the Mormon church and culture to grow. For
the Janssonists and Dowietes, the deaths of their founders brought new
leaders without the leadership abilities to maintain the loyalty of their
followers over the long term.

The three secular communities were the Icarians in Nauvoo, the Fourierists
in Loami and Pullman's employees in Pullman. Prior to joining the Icarian
movement, most Icarians had been raised Catholic. The Fourierists at the
Integral Phalanx had been and remained members of the Christian Church
and continued to practice that faith after the collapse of the community.
At Pullman, residents were encouraged to belong to the main Pullman

Protestant Church or to any other Protestant church they could afford to build and maintain in the community.

COMMUNITARIAN ECONOMICS VERSUS FREE ENTERPRISE. At Nauvoo, the Mormons gave up their previous attempt at communitarian economics as practiced in Kirtland, Ohio, and in Missouri. The Icarians practiced communitarian economics, as did the Janssonists. The Fourierists attempted communitarian economic practices, but that was one of the major reasons for the community's failure. Pullman was "a company town" run by George Pullman. At Zion, Dowie owned everything personally, although he gave the six thousand residents 1,100-year leases (100 years to usher in Christ's kingdom and 1,000 years for the Millennium; after 1,100 years, your personal property would be returned).

POLITICAL VERSUS APOLITICAL. In Nauvoo, politics caused the Mormons a lot of trouble. They had initially voted Whig, and then Democrat, as a bloc, causing antagonism and mistrust on both sides. The voting patterns of the Icarians, Pullman employees and Dowietes are unknown. However, Dowie did create a short-lived Theocratic Party. At Bishop Hill, the Janssonists were mainly apolitical, only turning out to vote twice in the history of the colony. The Fourierists at Loami were solidly Whig.

LEGAL PROBLEMS VERSUS NO LEGAL PROBLEMS. From an early age, Joseph Smith was bombarded with legal charges, and he was arrested a total of forty-two times. It was his order to destroy the newspaper the *Nauvoo Expositor* that led to his arrest, incarceration and eventual murder at the Carthage Jail. Jansson's argument with John Root over his female cousin brought him into court at Cambridge, where Jansson was murdered by Root. The Fourierists had minor disagreements over the dissolution of the community between those from the Sangamon Association and those from the Ohio group. In Pullman, the Pullman strike caused federal intervention to break the strike, for the first time ever, through legal injunction. Dowie continually practiced securities fraud and mismanaged his church's funds. In addition, he was charged with practicing medicine without a license.

IMMIGRANTS VERSUS NATIVE-BORNS. In Mormon Nauvoo, the town was made up of both native-born Americans and a large influx of English, Scottish and Canadian converts. Icarian Nauvoo was made up of French immigrants, while Bishop Hill was composed of Swedish immigrants. The Fourierists

at Loami were native-born Americans from the eastern seaboard and originally residents of Illinois or Ohio. Citizens of Pullman were primarily emigrants from Ireland, Italy, Germany and Holland. The Dowietes at Zion were mainly native-born Americans.

UPPER VERSUS LOWER ECONOMIC CLASSES. In all but the Sangamon Association Fourierists, the communities drew the majority of their members from the lower classes.

CONTEMPORARY SEXUAL BEHAVIOR VERSUS ATYPICAL SEXUAL BEHAVIOR. The average Mormon family followed traditional sexual mores of the time. However, beginning with Joseph Smith, many members, especially those in leadership of the church, were practicing polygamy in Nauvoo. The Icarians believed in traditional marriage and family; if someone were single, they were strongly encouraged to marry. At Bishop Hill, first celibacy, then arranged marriages and then celibacy again were attempted. The Fourierists at Sangamon County were made up of traditional families and marriages in spite of founder Charles Fourier's encouragement of open and casual sexuality. Traditional marriage and family were also practiced at Pullman and Zion.

EXTERNAL VERSUS INTERNAL CONFLICT. Three of the communities were allowed to achieve their destinies without outside interference: the Icarians at Nauvoo, the Janssonists at Bishop Hill and the Fourierists at Loami. However, for the Mormons at Nauvoo, the citizens of Pullman and the Dowietes at Zion, outside influences factored in the collapse of the colonies. At Mormon Nauvoo, the community had to deal with interference from the governor of Missouri, who continually sought Smith's arrest and return to face trial, as well as, finally, intervention by Governor Ford of Illinois and nearby city militias and angry citizens. The Mormons had attempted to create a complete social, economic, spiritual and political kingdom, causing much dislike and suspicion from the citizens of nearby towns. At Pullman, the employees of George Pullman went on strike, resulting in intervention by the federal government sending troops to break the strike. At Zion, Dowie had to deal with continuous lawsuits filed by medical professionals and county health officials.

All of the communities suffered from internal dissension of one form or another. At Mormon Nauvoo, dissidents left the church over the issue of polygamy and exposed the practice in the *Nauvoo Expositor* newspaper,

causing Joseph Smith to order the newspaper office and press destroyed. These events led to his arrest and incarceration, which culminated in the murder of Joseph and his brother Hyrum. At Bishop Hill, it was a second attempt at the restoration of celibacy, under the poor leadership and financial mismanagement of Jonas Olson, that led to the dissolution of the colony in 1862. A coup occurred at Icarian Nauvoo after Cabet returned from facing legal charges in France. He returned to find some Icarians no longer following his rules, and they eventually relieved him of the presidency of the colony.

Selfishness, resentment and jealousy overcame the Fourierists at Loami, with the Sangamon Association members becoming frustrated over the smaller economic contributions of their Ohio brethren and their failure to bring more members as they had initially promised. In 1894, at Pullman, four thousand employees of the Pullman Company began a wildcat strike in response to reductions in pay, layoffs in the workforce and the company's refusal to temporarily lower rent payments for housing at Pullman. At Zion, while Dowie was in Mexico trying to buy more land for another colony, Voliva deposed him and took over the leadership. Under Voliva's leadership, Zion split into two factions, eventually leading to the end of the Dowietes' community.

CONCLUSION

The leaders of the six communitarian groups in Illinois all advocated their separateness and the need for close association of all members. This was important for the effective instruction, criticism and supervision of their followers. The resources of "the haves" was needed to help the poorer brethren in Nauvoo, at Bishop Hill and at Loami. In Pullman, one tycoon sought complete control over his workers for his own gain under the guise of providing a utopia for the working man. At Zion, a con man controlled, and absconded with, the financial resources.

There were definite advantages to a planned economy in a communitarian society. If well managed, the community became a productive enterprise with rapidly increasing assets. Ideally, for most members of a commune, security and the abundance of joint assets were more important than opportunity for individual gain. However, individualism crept into the communities, with resentment and jealousy creating disharmony. Capitalism replaced communitarian economics. Capitalism reflects a belief in the innate self-interest of humans, and its practice can benefit the individual and their family, as well as their community and nation.

The Mormons, the Janssonists, the Fourierists, the Dowietes and the citizens of Pullman were all members of the Christian faith. The Mormons even added a supplemental text to the Bible, the Book of Mormon. All but the Icarian community looked to the early Christian church, during the time of Christ and immediately after, as the model to be followed.

CONCLUSION

The three religious communes had many similarities. They all believed in Christian perfection, seeking to build for themselves ideal utopias. They were all Milleniest, accepting the New Testament teaching of the second coming of Christ. All were spiritualistic and believed in miracles. The Mormons, Janssonists and Dowietes believed in healing by the laying on of hands.

With the exception of the Fourierists in the Sangamon Association, most members of the communities came from the lower socioeconomic classes and were poorly educated, naïve and overly trusting. They became members who were initially obedient to their strictly authoritarian leader or leaders. With the Mormons, several potential leaders sought followers after Joseph Smith died, although most Mormons followed Brigham Young to the West. Young was renowned for his superior authoritarian leadership and great organizational abilities.

Three of the six communes—the Icarians at Nauvoo, the Janssonists at Bishop Hill and the Fourierists at Loami—were allowed to live out their destinies without outside interference. The communes where outside interference occurred were the Mormons at Nauvoo, with citizens of nearby towns and the state governor stepping in; at Pullman, with federal troops intervening to end the workers' strike; and at Zion, where medical professionals and Cook County bureaucrats brought multiple lawsuits against Dowie.

While the other communes dissolved, the Mormons continued to survive and thrive to this day. The Mormons established their own lifestyle and settled in the West, some of their land in Deseret eventually becoming the state of Utah in 1896. Their entry into statehood was delayed forty-six years after the organization of the Utah territory because of the dominance of the Mormon Church and its unusual practices, especially polygamy. At Nauvoo, the Mormons had attempted to create a complete social, economic, spiritual and political kingdom. The community was in such contrast to the American culture at the time, and their stark differences made the Mormons an easy target for dislike and persecution. The pattern for Mormon society in Utah was laid out at Nauvoo; in Utah, the Mormon Church was able to achieve its goals without outside interference.

This pattern emphasized social organization and control, the marriage of church and civil government, the creation of a Mormon nation state within the United States until statehood, the integration of new immigrant converts and the practice of a polygamous family system. Also, at Nauvoo, the first accommodation to American culture by the Mormon Church was made by ending economic communitarianism. In Utah, the Mormons would give up political bloc voting and even polygamy. In 1890, President Wilford

Woodruff issued the First Manifesto, which advised against any future plural marriage. In 1904, the Mormon Church issued another political manifesto guaranteeing the separation of church and state and the church's intention not to encroach on the political rights of any citizen. This Second Manifesto also expanded the reach and scope of the First Manifesto.

Both Nauvoo and Bishop Hill lost their leaders in martyrs' deaths. An argument can be made that at both Nauvoo and Bishop Hill, the communes failed ultimately because of the respective sexual practices of polygamy and celibacy. At Nauvoo, the accusation of Mormon polygamy by the *Nauvoo Expositor* and the subsequent destruction of the press led to the Mormon abandonment of Nauvoo and migration to Utah. In Bishop Hill, the second attempt to reinstitute celibacy under Jonas Olson led to the dissolution of the colony in 1862. Coups occurred at Icarian Nauvoo, when Cabet returned from France to find some of his members no longer practicing what he had preached, and at Zion, while Dowie was in Mexico and Voliva took over.

Self-interest, resentment and jealousy overcame the Fourierists at Loami, as the Sangamon Association members became frustrated with the small contributions of their Ohio brethren and their lack of bringing in more members. The Sangamon Association members simply returned to their previous lifestyle, which they had considered satisfactory prior to forming the Integral Phalanx at Loami.

Following the Pullman Strike, the arrival of federal troops and a legal injunction, the Illinois Supreme Court ordered the Pullman Company to divest itself of the town, which was then annexed and absorbed into Chicago. The city of Zion continued to grow, with new churches and businesses, after Dowie and his successor, Voliva, died.

John Noyes, in his 1870 work, *History of American Socialism*, analyzed the causes for why many utopias failed. Noyes believed that most utopian communities acquired too much land and contracted heavy debts in doing so. The communes typically had nothing left to invest, produced insufficient crops and became unable to pay interest and redeem their loans. Noyes found that the religious communes were more stable than those based on political, philosophical or economic theories and practices. Noyes, remarkably enough, held the view that a utopian community could not be successful without some control of its members' sexual lives. He felt that firm leadership was necessary but that, at the same time, lack of internal democracy was a source of discord and rebellion. If and when classes emerged within the communities—such as a ruling elite, a civil service and the working masses—the utopia became corrupt and eventually

broke down. In the history of communes, collectivism often shifted to individualism, from commonly held property to private ownership and a money economy.

Mormon Nauvoo evolved into the phenomenal success the Mormon Church is today, as well as to the establishment of the state of Utah itself, while the other five communities became little more than fascinating, unusual and amusing footnotes in history. Of the six leaders, few people have ever heard of any other than Joseph Smith. The 2014 *Smithsonian Collector's Edition Magazine* ranked Joseph Smith the most important religious figure in American history. Historian Richard Bushman stated, "In the fourteen years he led the Church of Jesus Christ of Latter-day Saints, Smith created a religious culture that survived his death, flourished in the most desolate regions of the United States and continues to grow worldwide."

The same edition of the *Smithsonian Magazine* ranked Brigham Young the third most significant religious figure in American history. Young once said, "Mormonism has made me all that I am." Smith's genius gave birth to the religion, and Young's remarkable organizational and leadership skills allowed it to flourish.

Brigham Young was a craftsman from New York State and an early member of the church who never wavered in his loyalty to and belief in Joseph Smith. He led the main body of the Mormons from Nauvoo to the territory of Deseret (which today would comprise the state of Utah and much of California, Arizona and Nevada). Young was appointed territorial governor in 1851. He later made a bid for Mormon autonomy that prompted President James Buchanan to send federal troops to quell the Mormon Rebellion of 1857–58. According to historian and biographer John G. Turner, Young brought many of the key political issues of mid-nineteenth-century America to the forefront: westward expansion, popular sovereignty, religious freedom and vigilantism.

As the Mormons returned to Nauvoo to rebuild their temple and create a Mormon historical and spiritual center for today's members, new generations of Mormons await the day when they will return to Jackson County, Missouri. Once called there, they will build a temple on a dedicated site, complete the city of Zion, return to living the law of consecration and stewardship and return to the practice of polygamy. They believe that a place in Missouri named "Adam-ondi-Ahman" by Joseph Smith was the site of the Garden of Eden and that it will also be the place of the Second Coming of Jesus. This site is seventy miles north of Kansas City, Missouri, and is owned and maintained by the church. Only time will tell if the Mormons are right and we will see a new "Heaven on Earth."

NOTES

INTRODUCTION

1. Stockwell, *Encyclopedia of American Communes*, 3.
2. Ibid., 11.
3. Oved, *Two Hundred Years of American Communes*, 14–15.

CHAPTER 1

1. Hansen, *Mormonism and the American Experience*, 50.
2. Tyler, *Freedom's Ferment*, 87.
3. Ibid., 88.
4. West, *Kingdom of the Saints*, 17.
5. Roberts, *History of the Church of Jesus Christ of Latter Day Saints*, 18.
6. Ibid., 54.
7. Ibid., 55.
8. Nibley, *Joseph Smith, the Prophet*, 65.
9. Tyler, *Freedom's Ferment*, 93.
10. Arrington, "Early Mormon Communitarianism," 358.
11. Ibid., 44.

12. Flanders, *Nauvoo*, 97.
13. Stevens, "Life of Stephen A. Douglas," 342.
14. West, *Kingdom of the Saints*, 139.
15. Ibid., 140.
16. Ibid., 141.

CHAPTER 2

1. Pitzer, *America's Communal Utopias*, 281.
2. Cabet, *Toute la Vérité*, 85.
3. Cabet, *Travels in Icaria*, 231–33.
4. Sutton, *Les Icariens*, 44.
5 Etienne Cabet, *Le Populaire*, May 30, 1847.
6. Sutton, *Les Icariens*, 64–65.
7. Ibid., 62.
8. Cabet, *Travels in Icaria*, 44–45.

CHAPTER 3

1. Isakson, *Bishop Hill*, 38.
2. Ibid., 39.
3. Ibid., 40.
4. Ibid., 41.
5. Ibid., 42.
6. Elmen, *Wheat Flour Messiah*, 91.
7. Ibid., 96–97.
8. Ibid., 130.
9. Ibid., 151.
10. Swank, *Bishop Hill*, 39.
11. Elmen, *Wheat Flour Messiah*, 160.
12. Isakson, *Bishop Hill*, 148.

CHAPTER 5

1. Meyer, *Making the Heartland Quilt*, 1,182.
2. Power, *History of the Early Settlers of Sangamon County*, 513.
3. Rokker, *History of Sangamon County*, 946.
4. United States Census, 1850, Illinois, Sangamon County, 173.
5. Ibid., 211.
6. Guarneri, *Utopian Alternative*, 72.
7. Selby, *History of Sangamon County, Illinois*, 725.
8. Guarneri, *Utopian Alternative*, 72.
9. Dawson, "Integral Phalanx," 90.
10. Ibid., 88.
11. *Illinois History Journal* (1908): 90.
12. *Sangamo Journal*, March 20, 1845, 2:6.
13. Ibid.
14. Williams, *Culture and Society*, 28–36.
15. Deposition of Thomas Sowell, February 21, 1848, *Anderson et al. v. Williams et al.*, SANCC, IRAD.
16. *Sangamo Journal*, February 26, 1846, 4:1.
17. Dawson, "Integral Phalanx," 92.
18. Ibid.
19. Ibid., 93.
20. Ibid.
21. Ibid., 94.
22. Ibid.
23. Ibid., 95.

CHAPTER 6

1. Husband, "Story of the Pullman Car," 29; *Daily Democrat*, August 17, 1859, 1.
2. Glendinning, *Chicago and Alton Railroad*, 56.
3. Long, "Pioneer and the Lincoln Funeral Train."
4. Poor, *Manual of the Railroads of the United States*, vol. 13, 1,004–5.
5. Ibid., 1,087.
6. Buder, *Pullman*, 44.
7. Ibid., 50.

8. Ibid., 51.
9. Ely, "Pullman," 452.
10. Doty, *Town of Pullman*, 31.
11. Ibid., 51.
12. Ibid.
13. Ibid., 70.
14. Ibid., 71.

CHAPTER 7

1. Darms, *Life and Work of John Alexander Dowie*, 3.
2. Ibid., 3.
3. Gibbney, "Dowie, John Alexander," 95.
4. Ibid., 96.
5. Ibid.
6. Ibid.
7. Ibid.
8. *London Daily Mail*, October 24, 1900; Bowman, "Dowieism Exposed," 10–11.
9. Dowie, "American First Fruits," *Leaves of Healing*.
10. Harlan, "John Alexander Dowie," 117.
11. Swain, "John Alexander Dowie," 941.
12. Dowie, "San Francisco," *Leaves of Healing*, 5.
13. Blumhofer, *Assemblies of God*, 33.
14. Serle, "Dowie, John Alexander," 100.
15. Darms, *Life and Work of John Alexander Dowie*, 139.
16. Morton, "Big Con."
17. Gardner, "Flat and Hollow," 202.
18. Dolan, "Founder's Dream for a Perfect Christian City."
19. Dolan, "Way Back When the Prophet Voliva Flattened the World."
20. Ibid.
21. Ibid.

BIBLIOGRAPHY

Arrington, Leonard. "Early Mormon Communitarianism: The Law of Consecration and Stewardship." *Western Humanities Review*, no. 7 (Autumn 1953).

Blumhofer, Edith L. *The Assemblies of God: A Chapter in the Story of American Pentecostalism to 1941*. Vol. 1. Springfield, MO: Gospel Publishing House, n.d.

Boston, Kelly. *Utopian Socialism in Sangamon County: The Story of the Sangamon County Association and the Integral Phalanx*. New York: WorldCat Publishing, 2005.

Bowman, I.D. "Dowieism Exposed." *London Daily Mail*, October 24, 1900.

Buder, Stanley. *Pullman: An Experiment in Industrial Order and Community Planning, 1880–1930*. New York: Oxford University Press, 1970.

Cabet, Etienne. *Toute la Vérité*. Paris: Prevot, 1842.

———. *Travels in Icaria*. Syracuse, NY: Syracuse University Press, 2003.

Darms, Reverend Anton. *Life and Work of John Alexander Dowie*. Zion, IL: Christian Catholic Church, 1992.

Dawson, George E. "The Integral Phalanx." *Transactions of the Illinois State Historical Society* 12 (January 1907).

Dolan, Henry. "Founder's Dream for a Perfect Christian City." *Zion-Benton News*, September 30, 1984.

———. "Way Back When the Prophet Voliva Flattened the World." *Chicago American*, Saturday, January 3, 1959.

Doty, Mrs. Duane. *The Town of Pullman, 1893*. Chicago: Pullman Civic Organization, 1974.

Dowie, John Alexander. "American First Fruits." *Leaves of Healing* (1889).

———. "San Francisco." *Leaves of Healing* 7, no. 1 (April 28, 1900).

Elmen, Paul. *Wheat Flour Messiah*. Carbondale: Southern Illinois University Press, 1976.

Ely, Richard T. "Pullman: A Social Study." *Harper's Weekly* 70 (February 1885).

Flanders, Robert. *Nauvoo: Kingdom on the Mississippi*. Champaign: University of Illinois Press, 1966.

Gardner, Martin. "Flat and Hollow." *Fads and Fallacies in the Name of Science*. Mineola, NY: Dover Publications, 1957.

Gibbney, H.P. "Dowie, John Alexander (1847–1907)." *Australian Dictionary of Biography*. Vol. 4. Sydney, AU: Angus and Robertson, 1972.

Glendinning, Gene V. *The Chicago and Alton Railroad, the Only Way*. Dekalb: Northern Illinois University Press, 2002.

Guarneri, Carl J. *The Utopian Alternative: Fourierism in Nineteenth Century America*. Ithaca, NY: Cornell University Press, 1991.

Hansen, Klaus. *Mormonism and the American Experience*. Chicago: University of Chicago Press, 1981.

Harlan, Robert. "John Alexander Dowie and the Christian Catholic Apostolic Church in Zion." PhD diss., University of Chicago, 1906.

Husband, Joseph. "The Story of the Pullman Car." *Chicago Daily Herald*, August 17, 1859, 29.

Isakson, Olov. *Bishop Hill: A Utopia on the Prairie*. Stockholm: Lt. Publishing Huse, 1969.

Lindsay, Gordon. *James Alexander Dowie*. Dallas, TX: Christ for the Nations Inc., 1980.

Long, Charles. "Pioneer and the Lincoln Funeral Train: The Making of a Pullman Myth." *Railway World* (May 2005).

Meyer, Douglas K. *Making the Heartland Quilt: A Geographical History of Settlement and Migration in Early Nineteenth Century Illinois*. Carbondale: Southern Illinois University Press, 2000.

Morton, Barry. "The Big Con: John Alexander Dowie and the Spread of Zionist Christianity in South Africa." Paper presented at the University of Leiden, African Studies Center, June 20, 2013.

Nibley, Preston. *Joseph Smith, the Prophet*. Salt Lake City, UT: Deseret News Press, 1946.

Oved, Yacov. *Two Hundred Years of American Communes*. New Brunswick, NJ: Transactions Publishers, 2007.

Pitzer, Donald. *America's Communal Utopias*. Chapel Hill: University of North Carolina Press, 1997.

Poor, Henry V. *Manual of the Railroads of the United States*. Vol. 13, *Their Mileage Stocks, Bonds, Costs, Earnings, Expenses and Organizations. Together with an Appendix*. New York: H.V. and H.W. Poor, 1891.

Power, John Carroll. *History of the Early Settlers of Sangamon County, Springfield, Illinois*. Springfield, IL: H.W., 1876.

Roberts, B.H. *History of the Church of Jesus Christ of Latter Day Saints*. Salt Lake City, UT: Deseret Book Company, 1957.

Rokker, H.W. *History of Sangamon County*. Chicago: Interstate Publishing Company, 1881.

Ross, Marie. *Child of Icaria*. New York: Hyperion Press, 1975.

Selby, Paul. *History of Sangamon County, Illinois*. Salem, MA: Higginson Book Company, 1912.

Serle, Percival. "Dowie, John Alexander." *Dictionary of Australian Biography*. Sydney, AU: Angus and Robertson, 1949.

Stevens, Frank. "Life of Stephen A. Douglas." *Journal of the Illinois State Historical Society* 14 (1923–24).

Stockwell, Foster. *The Encyclopedia of American Communes, 1663–1963*. Jefferson, NC: McFarland & Company, 1998.

Sutton, Robert. *Les Icariens*. Urbana: University of Illinois Press, 1994.

Swain, J. "John Alexander Dowie: The Prophet and His Profits." *Century* 64 (1902).

Swank, George. *Bishop Hill: A Pictorial History and Guide* 16, no. 4 (October 1965). Swedish Pioneer Historical Society, Galva, Illinois.

Tyler, Alice. *Freedom's Ferment*. New York: Harper and Row Publishers, 1944.

West, Ray. *Kingdom of the Saints*. New York: Viking Press, 1957.

Williams, Raymond. *Culture and Society: 1780–1950*. London: Chatto and Windus, 1958.

INDEX

ABOUT THE AUTHOR

R andall J. Soland was raised in Nauvoo, Illinois. His love of history was fostered by his father, Robert D. Soland, and an elementary school teacher, David Fortado. Mr. Soland is employed as a full-time private practice counselor in Springfield, Illinois. He has Bachelor of Science degrees in history and psychology and secondary education from Western Illinois University. He has multiple graduate degrees, including a Master of Arts degree in history from Illinois State University.

Visit us at
www.historypress.net
..
This title is also available as an e-book